FROME
IN 50
BUILDINGS

ALASTAIR MacLEAY

AMBERLEY

First published 2024

Amberley Publishing, The Hill, Stroud
Gloucestershire GL5 4EP

www.amberley-books.com

British Library Cataloguing in Publication Data.
A catalogue record for this book is available from the British Library.

ISBN 978 1 4456 9231 9 (print)
ISBN 978 1 4456 9232 6 (ebook)

Typesetting by SJmagic DESIGN SERVICES, India.
Printed in Great Britain.

Contents

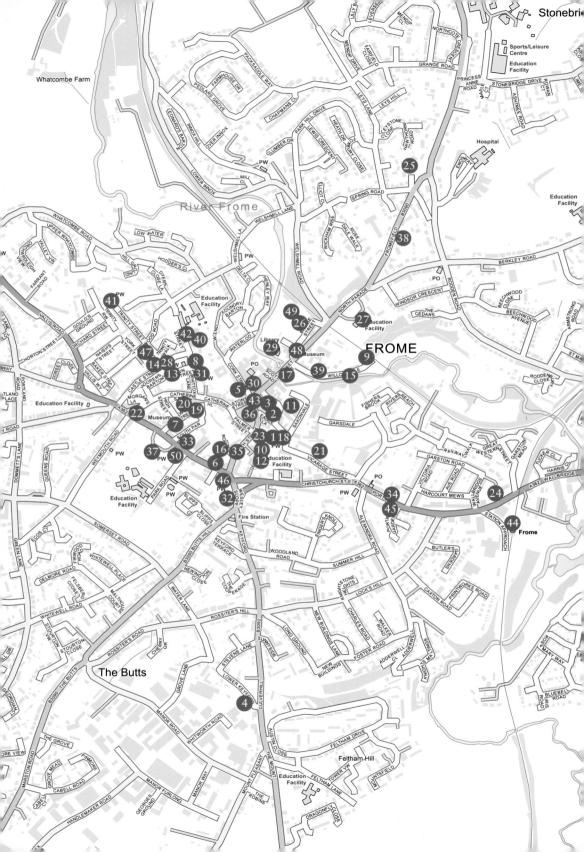

Key

1. St John's Church
2. Cheap Street
3. Apple Alley
4. Nos 55–67 Lower Keyford
5. Monmouth Chambers
6. Rook Lane House
7. Wine Street House
8. Melrose House
9. Queen Anne Terrace
10. The Hermitage & Chantry
11. Iron Gates & Court House
12. Gentle Street
13. Sun Street
14. Castle Street House
15. Willow Vale
16. Rook Lane Chapel
17. The Blue House
18. Bishop Ken's Sepulchre
19. Sheppards Barton
20. Catherine Hill House
21. Frome Vicarage
22. Ship Inn
23. Argyll House
24. Wallbridge House
25. Fromefield House
26. Market House
27. North Hill House
28. Lamb and Fountain Inn
29. Round Tower
30. George Hotel
31. Zion Congregational Chapel
32. Wesley Chapel
33. Rawlings Factory
34. Montgomery Court
35. Bath Street
36. No. 20 Bath Street
37. Christ Church
38. Brunswick Place
39. Feather Factory
40. Apex House
41. Holy Trinity Church
42. Vallis School
43. TSB Bank
44. Railway Station
45. No. 44 Portway
46. Wesley Villas
47. Selwood Printing Works
48. Frome Museum
49. Cheese & Grain
50. Town Hall

Introduction

I came to live near Frome in 1974 and remember visiting my local town the first weekend, walking along the narrow streets built on the hillside. The simple stone buildings dating mainly from the seventeenth to nineteenth centuries had survived and there had been little post-war development in the centre of the town. Frome had been fortunate that the 'slum clearance' of the Trinity area planned by Frome Urban District Council had been halted by the change in local government that year. This unique urban development had been saved by the outcry created by local architects, historians and the Frome and District Civic Society.

Aldhelm had founded a monastery at Frome in *c.* AD 685; he was a Saxon monk, a famous poet and singer, who became Abbot of Malmesbury and subsequently the first Bishop of Sherborne. Travelling between the two abbey churches, he built a wooden church on a plateau overlooking the ford on the River Frome. This formed the centre for the development of the town, which was on the edge of Selwood Forest. The town grew and a stone church was built *c.* 1000; the Domesday Book reports three mills on the River Frome and a market to serve the local area.

The town developed during the Middle Ages, influenced by its geography and local geology, to become an important centre where many tracks converged to cross the river and there was a ready source of suitable limestone together with timber from Selwood Forest readily available for building. Sheep farming on the Mendip Hills and Salisbury Plain were both major sources of wool and the fast-flowing River Frome provided both power and water to create the conditions for the development of the town as a centre for the wool industry. This was coupled with growing woad for dyeing in the Conigar and Trinity areas of the town.

Medieval Frome had already formed south of the river with the Market Place and Cheap Street, Stony Street and Palmer Street leading to St John's Church, then on up Gentle Street, (old) Rook Lane and Catherine Hill, all of which remain to form the current street pattern. By the end of the seventeenth century, there was a massive increase in the town's population and a 'New Town' was built on the fields beyond the western hillside. The population of the town quadrupled during 1665–1725, the principal growth taking place on the fields that belonged to three families who granted leases of ninety-nine years or for three lives. The houses were simple stone-built ones with thatch or stone tiled roofs, the latter only replaced by clay tiles or slate after the arrival of the railway in 1850. There are several larger

houses of contemporary date scattered among the artisans' and weavers' terraces of cottages, which had existed before the latter were built.

By the middle of the eighteenth century, Frome had grown to be larger than Bath and Taunton and was compared in size to Salisbury by Daniel Defoe in 1726. With the growth of the economy and the town population, there was a huge increase in Nonconformism which was shown by the building of many fine chapels beginning with Rook Lane Chapel (Congregationalist, 1707) and Sheppards Barton Chapel (Baptist, 1708), although the Quakers' first Meeting House dated from 1675. The major clothiers and later nineteenth-century industrialists were, with some exceptions, nonconformists. In addition to building or contributing to the chapels' construction, they either built or bought their fine family houses on the outskirts of the growing town and many of their houses are described in this book.

Frome has been particularly fortunate that its original medieval street pattern can still be traced and that the inevitable changes brought about by nineteenth-century building have only caused minor losses; however, around half of the Trinity area, developed from the late seventeenth century and one of the finest examples of planned industrial housing in Western Europe, was lost in the name of modern development in the 1960s.

The 50 Buildings

The parish church of St John the Baptist was founded *c*. AD 685 as a monastery and mission church by Aldhelm, Abbot of Malmesbury and first Bishop of Sherborne. The church would have been a timber structure, which was rebuilt in stone *c*. AD 1000 and there was a further rebuilding in 1166. Little remains of these apart from two sections of a Saxon cross, which show coiled serpents and an equine quadruped now built into the base of the tower, a piscina and a fine Norman archway.

St John's is today a good example of nineteenth century and particularly Victorian architecture.

In 1814, Jeffry Wyatt, George IV and Lord Bath's architect, opened up the approach from Bath Street with a forecourt, stone screen and new western facade. When Revd William James Early Bennett was appointed vicar in 1852, he wrote:

> The church! alas! Is a mere ruinous heap … a crumbling mass ready to fall down about our ears … the tottering spire … these stones crumbling away to ruin, and moss and lichen creeping along the cornices … See here the walls, misshapen and distorted, overhanging their own base, these windows without vestige of their mullions, patches and props of every hue and shape …

Bennett raised a fortune from parishioners and used his own money to rebuild, remodel and reform worship at St John's, using the Frome-born architect C. E. Giles. Bennett was a leading proponent of the Oxford movement and he arranged for a complete reconstruction of the church to comply with his Tractarian principles; sadly, most of the medieval and later features were lost during the reconstruction.

The church is a long low building; the nave is 34 metres long with a fine timber roof and side arches. There are a series of medallions above the pillars sculpted by James Forsyth. Those on the north side show Christ's miracles and those on the south side show His parables, which Bennett used as a teaching aid. The rood screen separating the chancel with its fine hammer-beam roof was designed by Kempe and made in Oberammergau, Bavaria. The wrought-iron screen leading into the Lady Chapel was made by Singers of Frome. There are stained glass windows by Clayton & Bell and Kempe.

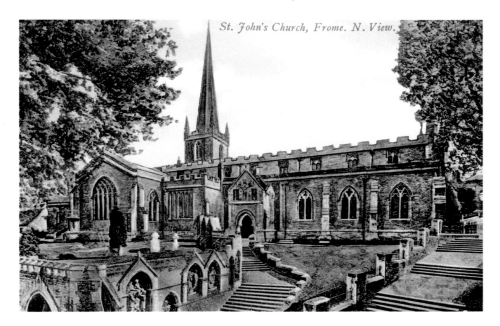

St. John's Church, Frome. N. View.

Above: St John's Church
from the north.

Right: St John's Church
from Vicarage Street.

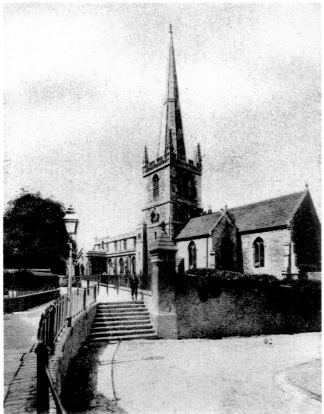

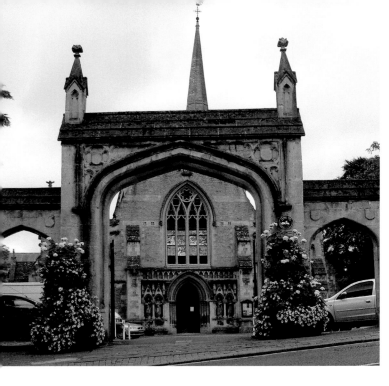

Stone screen and western façade, St John's Church.

The Via Crucis with six stations of the cross leads from St Aldhelm's well to the Crucifixion above the north porch. This set of sculptures, also by James Forsyth, unique in Anglican churches in Britain, provided a ritual entry for procession to the church.

The whole effect is an outstanding memorial both to the founder of Frome, St Aldhelm, and to the Oxford movement.

St John's Church is listed Grade II*.

Via Crucis, sculpted by James Forsyth.

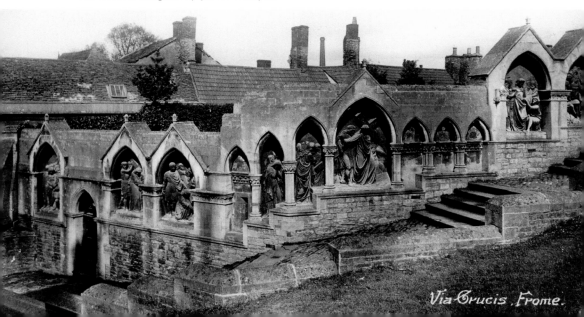

2. Cheap Street

This is the oldest trading street in Frome: the street of the chapmen (itinerant merchants); it leads up the hill towards St John's Church and it is the street for which Frome is best known. Originally there would have been wooden stalls on either side of a path leading from the Market Place, which in due course were rebuilt in stone and then replaced by houses with shops on the ground floor. The oldest reference to the street is in 1500 when a butcher bought a vacant plot to build his shop. Although the shopfronts have regularly been altered every fifty years or so, the backs of the buildings reveal their age with their jetties (projecting upper floors) reaching out over Apple Alley to the north. Most of the buildings are timber framed and some of the heavy trusses can be seen from the street; No. 11 has Tudor roses carved into the oak beams supporting the first floor behind a *c.* 1900 shopfront, which dates the building from *c.* 1530 and is the finest example of a timber-framed building in Frome. Most of the houses date from the sixteenth and seventeenth centuries but are hard to categorise owing to the alterations which have taken place over at least 400 years. There was a fire in 1923, which demolished Nos 9 and 10, having spread from No. 17 opposite; the former have been replaced by a mock half-timbered building whereas No. 17 was rebuilt in stone to an uninspiring design.

Cheap Street from Frome Market Place in 2020.

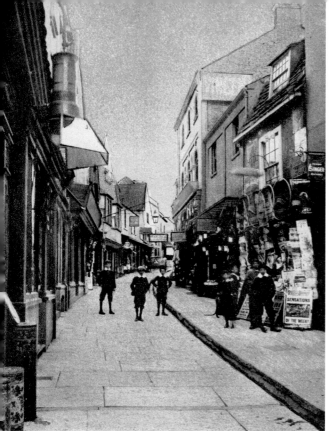
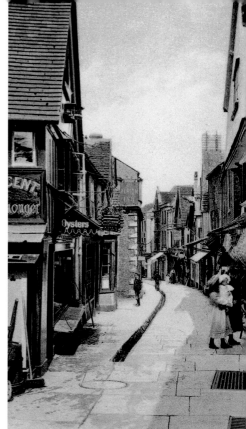

Above left: Cheap Street from Market Place with bluecoat boys, *c.* 1900.

Above right: Cheap Street looking towards Market Place, *c.* 1900.

There is a leat (stream) that runs down the centre between the stone flags. The water level, temperature and flow rate remain constant throughout the year, independent of the rainfall or outside temperature. During the drought in 1976 and 2022, the leat ran exactly as it does today: same level, same rate, same temperature. This is one of the many streams that rise in the East Mendips which provide springs throughout the southern slopes of the town. It runs under the graveyard of St John's Church, leading to the saying attributed to the Frome worthy, Thomas Bunn, that 'a fine spring flowing through the churchyard ... among coffins and skeletons ... he had heard that it was good to have body in wine, but he had never heard that it was good to have body in water'. The leat used to supply the Boyle fountain and cross in the Market Place, which was installed in 1871.

3. Apple Alley

Apple Alley used to be called Leg of Mutton Lane because of the shape of the block of houses between Cheap Street and King Street. It is only 2 metres

Above left: Apple Alley with pigeon loft and jettied buildings.

Above right: Lithograph of Apple Alley.

wide and shows the back of the sixteenth-century houses on the north of Cheap Street; some of these have jetties as they were built out over the narrow alleyway. They would have been met by similar jettied buildings opposite before the latter were demolished to develop King Street. It is only from the back of the houses that their age can be gauged. Apple Alley recalls the medieval passages that existed in the centre of Frome before Bath Street was cut in 1812. It was repaved with sandstone flags by the Frome and District Civic Society in the 1990s so that it now represents a typical narrow medieval street. One house still has the original holes for pigeons' nesting boxes that provided squabs and pigeons eggs for the owner. Another striking feature is the change in ground level; for instance, the threshold of No. 4 is now 60 cm below the current level whereas there would have been a step up to stop flooding from the River Frome into the building.

4. Nos 55–67 Lower Keyford (Keyford Manor House)

This group of two-storey cottages incorporates the vestiges of the oldest house in Frome. The thick walls still contain several medieval door and window arches. The Grade II listing describes Nos 59 and 61 as rendered rubble with pantile roofs with the front of No. 61 showing a blocked two-light medieval window with moulded stone mullion and trefoiled heads. Nos 63–67 are rubble with block dressings while Nos 55 and 57 form a rear wing to Nos 59 and 61.

It was from Keyford Manor House, the original building, that Ankarette Twynyho was abducted by Richard Hyde of Warwick and Roger Strugge, a clothier, of Beckington together with twenty-four of the Duke of Clarence's henchmen who had broken in without warning or warrant on Saturday 12 April 1477. She was well known as a quiet and peaceable widow, but the Duke suspected her of poisoning the Duchess of Clarence in December 1476, to whom she had been a lady-in-waiting, with 'a venomous drink of ale mixed with poison'. Although she pleaded her innocence, she was taken to Bath, thence to Warwick Castle, where she was summarily tried by a kangaroo court, found guilty and hanged within three hours.

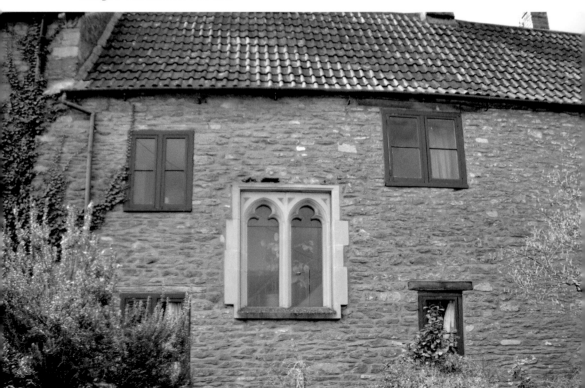

No. 55 Lower Keyford with ashlar trefoil double window.

In 1685 the Duke of Monmouth's army stabled horses here at 'The Old Nunnery House' during the rebellion, but the house had become ruinous and may already have been subdivided when visited by the historian John Strachey in 1740. At some time, the whole building had been rearranged both horizontally and laterally to create a row of cottages. The house was painted by W. W. Wheatley in 1845, which showed an impressive two-storey porch, opening on to a courtyard; the porch, which was demolished in 1850, was in front of No. 57 to form the courtyard of the small manor; the front of Nos 59 and 61 was originally the back of the house. The cottages were altered in the 1850s after which they were allowed to deteriorate. After a further hundred years without proper maintenance, they had again become semi-derelict by the middle of the twentieth century.

When they were renovated in 1979, a fine late fifteenth-century painting depicting Jesus and two of His disciples was discovered, preserved and put behind glass; this could well have been associated with the portable altar which Pope Calixtus III had permitted the Twynyho family to install. There were further wall paintings, but they had been badly damaged by earlier plaster, and they had become too indistinct to be able to recognise their subjects. They were covered up in the hope that they might be renovated at a later date.

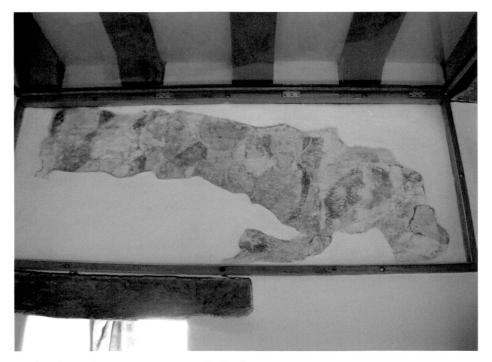

Medieval painting at No. 55 Lower Keyford.

5. Monmouth Chambers, Nos 3 & 3b Cork Street

This is the house dating from *c.* 1650 where the Duke of Monmouth is said to have stayed on 18 June and during his retreat after the skirmish at Norton St Philip, on 29 June 1685. When he first entered the town with his peasant followers, he had been declared 'King' by the constable, Robert Smith, who pinned up a proclamation in the marketplace. Retribution came quickly in the form of the Earl of Pembroke with a squadron of cavalry and some musketeers from Trowbridge, who tore down the paper and arrested the constable for treason. He was later condemned to death but escaped with being deported. Monmouth stayed in Frome until 30 June before leaving for Shepton Mallet and his final defeat on Sedgemoor, the last battle to be fought on English soil.

This three- and four-storey building is rubble built under a pantile roof. It had been greatly altered during the eighteenth and nineteenth centuries and was left derelict for many years during the mid-twentieth century; it was rescued from demolition by Dorothy Brown, who brilliantly restored it, retaining all possible original features. It has two fine attic gables, although there were originally three or possibly four gables; No. 3 is original with coping and parapet and No. 3b to the right has a dormer over a plastered timber-framed second floor. On the first floor there are deeply transomed and mullioned windows and the sole plaster

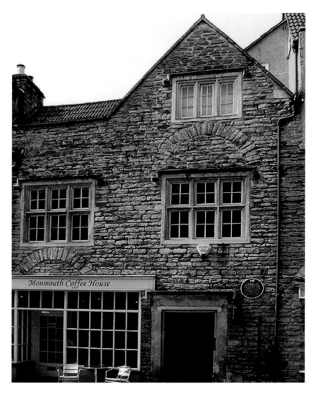

North elevation, Monmouth Chambers, Cork Street.

ceiling left in Frome in a first-floor room (following its transfer to the Priory Barn in Bradford on Avon from another mid-seventeenth-century house in Merchants Barton, which was later demolished). The design is of vine leave scrolling, with a shield and griffin frieze. There are deeply transomed windows at first floor level. Monmouth Chambers are listed Grade II*.

6. Rook Lane House, Christchurch Street West

The Smith family was one of the most important clothier families in Frome, owning Leonard's Mill. They built two outstanding seventeenth-century houses: Rook Lane House and Stonewall Manor in Keyford. Following the Act of Uniformity in 1662, the minister at St John's, Dr Humphrey, left the church with many of the congregation and met at Rook Lane House; indeed Robert Smith leased and later sold the orchard of Rook Lane House on which Rook Lane Chapel was built in 1707. Rook Lane House itself dates from the early 1600s with rubble walls and large triple gables, under a stone tiled roof and stone chimneys. There are relieving arches over the window openings, typical of the time, although the

Rook Lane House, Christchurch Street West, with Sydney House attached.

attic windows are probably only those that are original . There is a very obtrusive late nineteenth-century neo-Gothic bay window that obscures the balance of the building. However, there is a fine late eighteenth-century door in an architrave opening with cornice hood, which served as the main entrance. The house was built on the old Rook Lane, which would have run immediately in front of the building until Bath Street was cut. There is an extension dated 1898 which is out of keeping with the original building with an archway over the line where the original Rook Lane had been. It became the home of the well-known, but mainly forgotten poet Elizabeth Rowe, née Singer (1674–1737). She had become a friend of Bishop Thomas Ken and wrote religious texts and moral poems which were translated into several European languages and read throughout the eighteenth century. Her particular inspiration came from meditation in Vallis Vale. She died at Rook Lane House in 1737. An example of her poetry is 'On the Picture of King George I':

> Such native goodness, such regal grace
> Was never stamp'd on any vulgar face;
> The sacred characters so clearly shine,
> 'Twere impious not to own the right divine.

Rook Lane House is listed Grade II.

7. Wine Street House

Wine Street House is surrounded by several buildings in the terrace of Wine Street, which was built around it. The oldest part of the house is the rear gabled wing with stone mullion windows and stone tiled roof, which dates from *c.* 1650 and appear in a conveyance from Honor Champneys to John Sheppard, whereas Wine Street was developed by William Sheppard in the 1730s. The front section of Wine Street House was added just before 1740, probably built by Thomas Lacey, a carpenter who would have also made the main staircase. The house was leased to his brother, another John Sheppard, who lived there until his death in 1795. The Sheppards continued to own it for nearly 200 years until 1847 when it was given to Sheppards Barton Chapel, next door, by a third John Sheppard. The chapel held the freehold until 1961.

It is possible to trace the development of the building from the original seventeenth-century cottage at the back to the eighteenth-century front rooms, particularly, the panelled drawing room to the south and early nineteenth-century rooms at the back. The latter are at a different level and probably served as workshops for John Sheppard, before being used for a brewhouse.

The building was variously used as a school for eighty years by the Miss Smith, Mrs Edwards and later the Miss Coombs who ran their private ladies school,

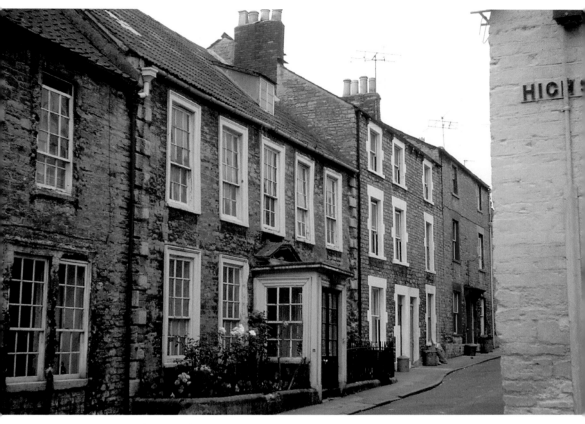

Wine Street House from High Street.

'Selwood School'. It was here that Katharine Harris was sent as a two year old by her Baptist missionary parents, John Hobbis and Alice Seeley Harris for her education. Later, as Katharine Ashworth, she bought the house and gave it to the Frome Society for Local Study to house Frome Museum where it moved from Church Steps in 1975, before moving to its current central position next to Frome Bridge in 2000.

Wine Street House is now a private house and listed Grade II*.

8. Melrose House, Whittox Lane

Walking down Whittox Lane, which joins Catherine Hill with the Trinity area, one is struck by the façade of the finest clothier's house in Frome. This Grade II* listed building built by William Whittock in the 1690s stands at right angles to the road, indicating that, probably, it was originally built on a route from the town centre to New Town, as the Trinity area used to be

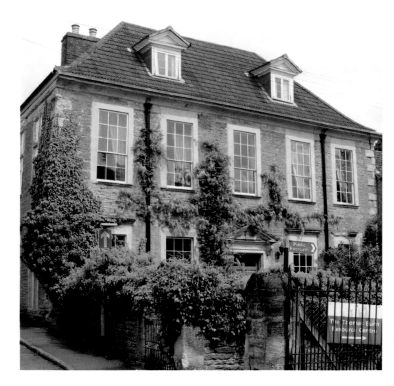

Melrose House from Whittox Lane.

called. The three storeys with partial basement are perfectly proportioned. The magnificent façade, under a hipped pantile roof with two gabled dormer windows, has five bays with transom windows with stone crossbars and mullions; above the main entrance with six panel doorway, which is reached by a flight of five steps, there is a broken pediment encasing an urn. There are blocked windows on the west wall indicating late seventeenth-century construction.

The interior is only one room deep and has an imposing central staircase, and there are seven eighteenth-century oil paintings behind the blind windows which depict local hunting scenes. These windows were probably blocked to avoid paying the window tax introduced by William III in 1696. The original owner would have been a rich clothier living close to his homeworkers whose houses had recently been built a short distance away. The building has had many uses including the reception of the Sisters of St Louis, a Roman Catholic community, who came to Frome in 1902. The house was converted to flats after the Second World War, but fortunately the major interior features were not damaged. After a long period of decline and dilapidation it was magnificently renovated by Ivan Massow, sometime chairman of the Institute of Contemporary Arts, at the end of the twentieth century.

Melrose House has now been separated into two houses. Melrose is listed Grade II*.

9. Queen Anne Terrace, Nos 14–16 Willow Vale

This magnificent terrace, at the east end of Willow Vale, was possibly built *c.* 1720
by James Smith, a clothier. The three houses have austere stone shell hoods
protecting the grand entrances, which are each reached by a flight of steps to lift
the houses above the basements, which would have been flooded every winter.
Walls are coursed rubble with ashlar dressings, pantile roofs and gabled dormers
grouped 3+3+2. The sash windows are grouped 5+5+3. Tall and slim, they create
an elegant effect. The three houses were built separately; the first two, Nos 14
and 15, each has five bays, whereas No. 16 has three. This does not upset the
balance of the group where all are listed Grade II* as an ensemble. The exact
sequence of construction is not certain, but internal evidence suggests that Nos 15
and 16 were one house before being separated, probably in the early nineteenth
century. James Smith is mentioned in the Church Rates as the owner of No. 14
in 1723 and it was home to a series of clothiers, dyers and professionals over
the next 300 years. No. 15 was occupied by a clothier, Peter Chapman, by 1742,
after which the 1,000-year lease passed to Josiah Ames, another clothier. In 1804,
this was acquired by James Anthony Wickham, after which there were a series of
tenants during the nineteenth century. Wickham was probably responsible for the
conversion to two houses since the first mention of No. 16 is with Joseph Gainer
in 1821. There would have been workshops attached to No. 14 and beyond
No. 16. The latter were bought by the GWR and partly demolished to allow for

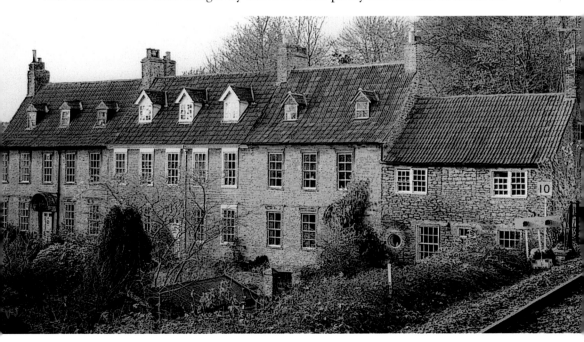

Nos 14–16 Willow Vale from the mineral railway.

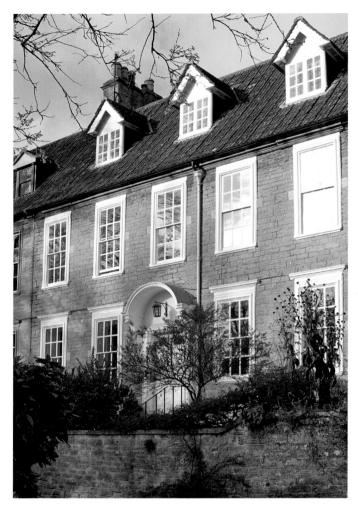

No. 15 Willow Vale.

the construction of the railway in the early 1850s, leaving No. 17 with a blocked window and doorway next to the track. Apparently a steam train driver used to stop here regularly and have his kettle refilled with water.

The designers of the buildings are not known, but the houses have provided homes for dyers, clothiers and professional people for 300 years.

10. The Hermitage/Chantry

The Hermitage and Chantry were built as one house on land in Hungar Lane (now Gentle Street) that had been occupied by a cottage and was bought by the Thynne family (the Lords Bath of Longleat) in 1548 to become their townhouse in Frome. It became Gentle Street House after being purchased by James Wickham III,

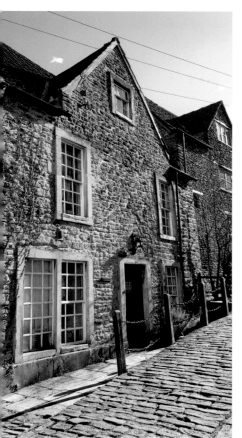 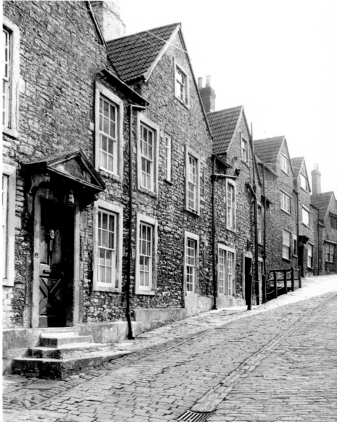

Above left: The Hermitage, Gentle Street.

Above right: The Chantry, Gentle Street.

the solicitor, who had built the Blue House in the 1720s and given the latter to
Frome. The Hermitage/Chantry was a typical sixteenth-century building with stone
mullions and casement windows, which were replaced by the more fashionable
sash windows by James Wickham after he bought the tenancy. It is still possible
to see the original stone surrounds into which the sash windows had been placed.
There are hung sashes in pairs to the ground and first floor, mid-eighteenth century
on the left and early nineteenth century with larger panes and thin glazing bars.
The impressive doorway has a fine pediment on shaped brackets and the door with
crossed panels both date from the late eighteenth century.

The Wickham family of solicitors had been tenants for most of the eighteenth
century before it passed to Dr Francis Bush, a surgeon, in 1814. After his death
in 1843, he was succeeded by his son Dr Francis John Bush, who only outlived
his father by two months. Both Dr Bushs were very popular and Stephen Tuck,

a bookseller in Whittox Lane, wrote a twelve-verse poem as a eulogy to Francis Bush Sr, which began:

A wondrous Bush for many years,
Except few weeks* was in full bloom;
Whose balmy influence it appears
Brought ease and health and joy in Frome.
Who can describe that lovely Bush
Whose flowers and fruits crown all the year?
Whose medicines did diseases hush
And from afflictions raise and cheer.
Did not his funeral awe the town?
The shops were closed, and silence reigned,
While hundreds four-a-breast moved on,
In mourning neat, like soldiers trained.
Gentry and Ministers in train,
Some poor and numerous Tradesmen too,
And thousands with respect came then,
To bid his last remains Adieu.
*Dr Bush had broken his leg.

Although he was no relation, the practice was taken over by Dr Edwin Bush, who ran it successfully for many years, after which it was used as a school. The freehold of the Hermitage was sold by the Longleat estate in 1922; it was split in two in 1948. Both the Hermitage and the Chantry are listed Grade II*.

11. Iron Gates and the Court House

Iron Gates was built in the late seventeenth century, being first rated in 1696, and the Court House was built at right angles to the rear wing of Iron Gates. These elegant houses were occupied by clothier brothers William and John Sheppard by the mid-1740s. They were both magistrates, although there are no records of formal hearings taking place there. However, prisoners are said to have been held in the cellars. The position of their houses was convenient for the Town Mill, together with the dyehouses in Willow Vale, which were only a minutes' walk via a footbridge across the River Frome. These houses both underwent major alterations during the mid-eighteenth century.

Iron Gates stands north of Church Steps for which there is an imposing view directly down King Street to see the fine two-storey façade of five bays with a high parapet in front of a stone tiled roof. There is a plain panelled door under a broken pediment; during renovations in the late 1970s, the rubble stone front was rendered and grooved to give the impression of ashlar. This has changed the character of the

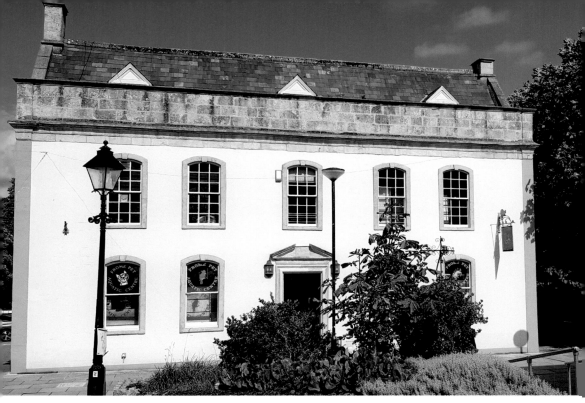

Iron Gates, King Street, after rendering.

Iron Gates, *c.* 1910.

building completely, although it still remains a striking example of Frome's elegant buildings. There is a glazed porch with a panelled door at the back entrance and there is a lead rainwater head with a shield showing the Houlton coat of arms.

The Court House also has a two-storey façade of seven bays under a stone tile roof with three dormers, the central with a segmented head and the two outers are gabled. The sash windows are arranged 2-3-2 in ashlar architraves with the central standard window between two narrow examples. There is a fine semicircular shell hood incorporating a carved motif on carved brackets, covering three steps leading to the main entrance.

Both Iron Gates and the Court House are listed Grade II*.

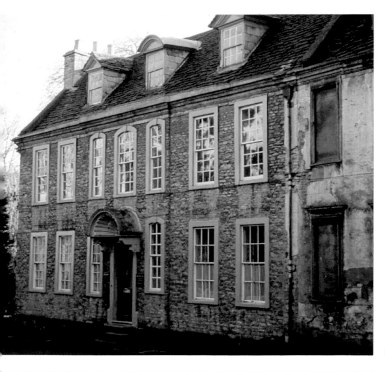

Court House, *c.* 1970.

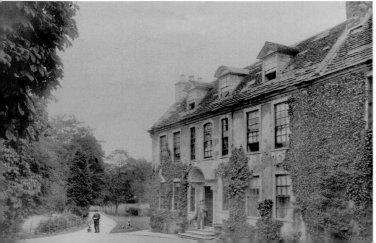

Court House, *c.* 1890.

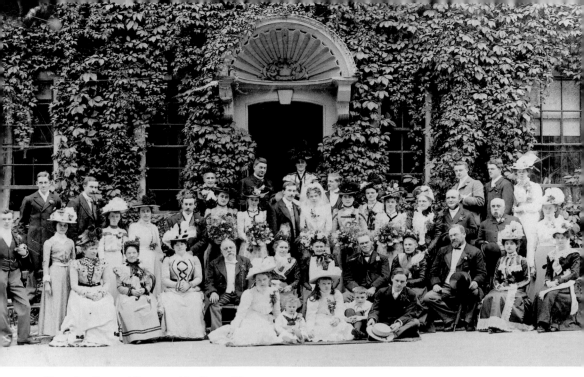

Knee family wedding outside Court House, *c.* 1900.

12. Gentle Street

This steep cobbled street, together with Rook Lane, were the two main routes south out of Frome until Bath Street was cut in 1812; they must both have been dangerous for wagons and carriages in winter. It was called Hungar Lane (steep slope in old English) in the Middle Ages until it took its current name from William and Alice Gentell who lived there in 1540. The road rises sharply from the forecourt in front of St John's Church. It became the home of solicitors and doctors from the late seventeenth century for over 200 years, who lived in the Hermitage and Chantry. In late the eighteenth and early nineteenth centuries Argyll House and Oriel House were built opposite the churchyard and Dr Francis Bush built Knoll House in 1839 for his son. This fine Victorian mansion was later owned by J. W. Singer, whose son, Edgar, left it as a home for the British Legion. It has now been converted to flats.

Further up the hill, the Waggon & Horses was an inn for 400 years from 1560 until closure in 1960. It was the starting point for the stagecoaches to London using the 'Frome Flying Wagon', which left Clavey's Barton, the yard behind the pub, at one on Monday mornings and reached the Kings Arms, Holborn, at midday on the following Wednesday. The cost to travel to London was £1 7s. After closure, the building was taken over by the Urban District Council, converted into flats and suffered considerable damage by the tenants. It has lately been sold and repaired, so that the fine double gabled house can be fully appreciated.

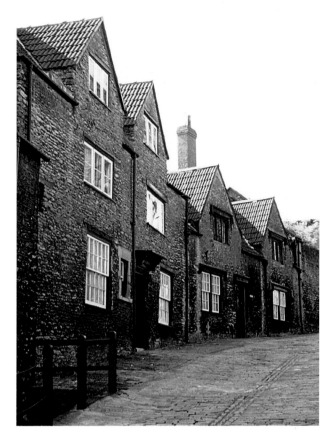

Left: Gentle Street rising to the south.

Below: Gentle Street descending with the Waggon and Horses Inn, *c.* 1950.

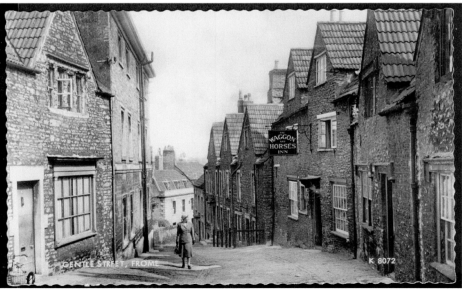

The top of the hill is dominated by the Lamb Brewery maltings, which were later converted to a bottling stores before closure in 1959. The double kiln above the malting floors has been finely restored overlooking Gorehedge, the triangle where the brewery once stood. Both the top and bottom of Gentle Street are marked by fine examples of Cockey lamps.

13. Sun Street, formerly Mathews Barton

Before the start of the construction of New Town in the late seventeenth century, there was probably a pathway through 'Culverclose' leading up from Hill Street (now Cork Street) that was aligned on Zion Path, the latter shown as a watercourse on the first map of Frome in 1774, hence explaining the orientation of Melrose House (qv), which is currently at right angles to Whittox Lane. This pathway would have extended via Mathews Barton to the 'oad grounds', where woad was grown for use in dyeing wool for blue cloth.

Sun Street would have been developed concurrently with New Town in the late seventeenth century since No. 15, Reprieve Cottage, has a date stone 1690 and an oculus window which were discovered during renovation in the 1990s. Although

Below left: Derelict Sun Street in 1974.

Below right: Sun Street restored in 1995.

Above: Sun Street, *c.* 1985.

Below: Sun Street in 2000.

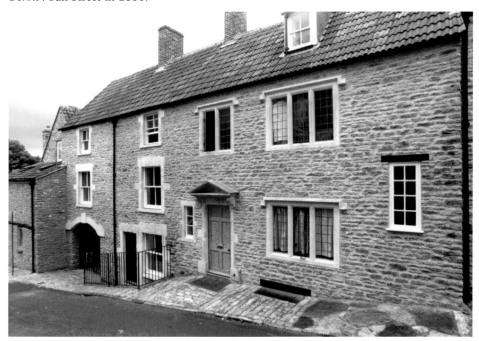

only one room deep, No. 3 was built to impress with a grand porticoed entrance, stone mullion windows and a fine winder staircase over an inglenook fireplace. Indeed, it is difficult to understand why such an ostentatious façade would have been put on a house consisting of one room up and one down, without foundations, built above an earlier cellar. The street had become very run down; this was exacerbated in the 1960s when there was a plan to build a new road from Cork Street to Badcox, leading to the compulsory purchase of those houses in the line of the planned road. This blighted the east side of the street for twenty years so that it became vandalised and derelict. Since no funds were forthcoming for this road, three cottages were restored by the Sun Street Trust in the 1980s until it became bankrupt and the northern section of five cottages and a coach house were renovated privately to an outstanding scheme by Frome architect Bruce Yoell. Several of these cottages are now listed Grade II. The severe Sun Street Chapel of the primitive Methodists is hemmed in between cottages on the west side of the street.

14. Castle Street House (The Keep)

This building at No. 23 Castle Street has 'The Keep' carved above the main entrance, but this is a misnomer since there was never a castle in Frome! In fact, the street was named after a certain Mrs Castle who had lived there in the 1730s. Although the building was constructed in the late seventeenth century, it has five bays and was refronted during the early eighteenth century in brick, English garden bond and ashlar to create a fine Georgian façade. The brickwork is completely alien, particularly to the Trinity area and the rest of Frome, which are built in rubble stone with freestone window and door surrounds. The nearest brickworks were at Flintford on the road to Warminster and at Rode, so would have been an expensive way to display the owner's wealth.

During the mid-nineteenth century, the house was owned by William Butler, who had been the partner of William Langford, who started printing labels in the Wheatsheaves Inn yard for his pharmacy at No. 20 Bath Street. The printing press was moved to the garden in Castle Street House while Langford continued to concentrate on his pharmacy and producing the Frome Almanack, while Butler developed the printing business. In due course Langford retired from the partnership and Butler took on Joseph Tanner as a partner. With expanding trade, a new printing works was built on the bottom of the garden during the 1860s, which in turn was extended as the business grew. During recent renovation, several external features such as windows and wooden gutters were found internally, which indicated the house had been created from two cottages as well as certain details of the Spread Eagle Inn that remain in the courtyard. There was also a maltings to the west, which has been replaced by two garages. Castle Street House was used as the Frome cottage hospital from 1875 to 1900; it closed after the Victoria hospital was built in Park Road. Castle Street House is again in private hands and listed Grade II.

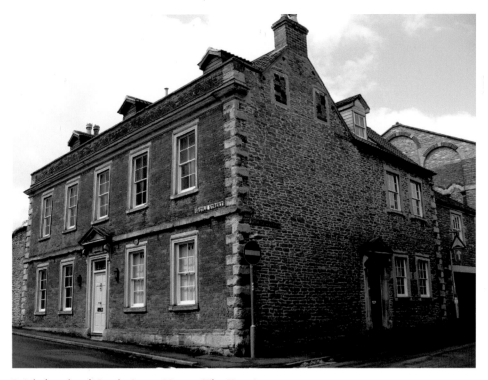

Brick façade of Castle Street House (The Keep).

15. Willow Vale

This elegant street just north of the River Frome was a hive of industry for centuries but has now taken on an air of tranquillity as the river flows quietly by. The Sheppards' town mill has disappeared completely, although the river now follows the line of the mill leat after alterations to the course of the River Frome in 1970; these have alleviated the regular flooding of cellars of houses in Willow Vale and Frome Market Place.

There is a floor maltings that can be seen through a short passage, which was built by Thomas Balne in 1808 and used to supply the local inns with the malt for their own brewhouses. Willow Vale was the centre of the dyeing industry in Frome, which was run by the Allens and Olives, as well as the Sheppards. One of the houses set back from the river still has an undercroft where woad was fermented. Many other stone buildings, now converted to houses, were used for making the blue dye from woad used to colour the cloth for which Frome was famous. There is a derelict tower, tucked away behind extensive dyeworks, which was used to dry the cloth after dyeing.

A four-storey warehouse was known as the feather factory leads to a yard that had a coach house with livery stables, later used by the Frome Fire Brigade.

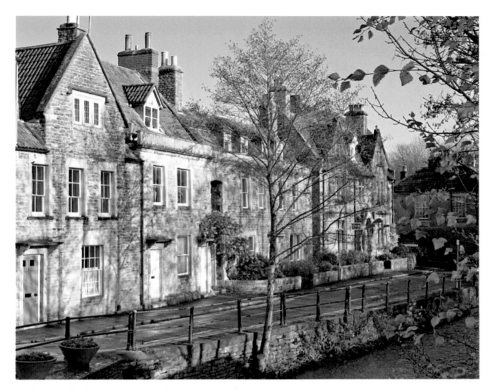

Willow Vale from Frome Bridge.

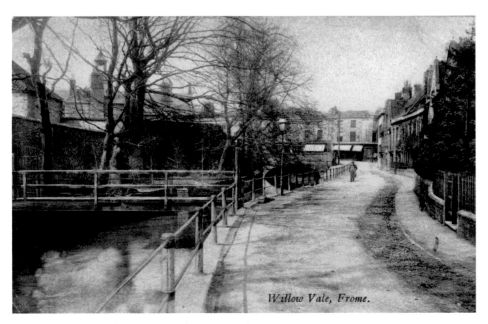

Willow Vale with Blue House and Frome Bridge, *c.* 1930.

Halfway down Willow Vale, beyond more converted dyehouses, the industrial buildings are replaced by the elegant Willow Vale House with a fine columned portico and ashlar façade, which was built *c.* 1733 by Mary Allen; later it was owned by the Olive family, who extended it with an additional building in the same style, called The Willows. Riverside Terrace, a group of five 1930s houses designed by Frome architect Percy Rigg, was built by Sir John Harris, a retired Baptist missionary whose wife Alice (née Seeley) had photographed the atrocities committed in the Congo Free State. They toured Britain, continental Europe and the United States lecturing about the conditions in the Congo; Alice Seeley's photographs were the proof that led to King Leopold II ceding his personal ownership of the country to Belgium.

Willow Vale is completed by the terrace of three fine Queen Anne-style houses.

16. Rook Lane Chapel, Bath Street

Frome was a centre for Nonconformists where the oldest surviving chapel was built in 1707 for the Congregationalists on land belonging to Robert Smith, a wealthy clothier of Rook Lane House. The first minister for forty-three years was Revd John Bowden with a congregation that had grown to 1,000 souls in 1717. A later minister was John Sibree who was responsible for the first Sunday School in Frome in 1795 and later founded the London Missionary Society.

Rook Lane Chapel before restoration, *c.* 1990.

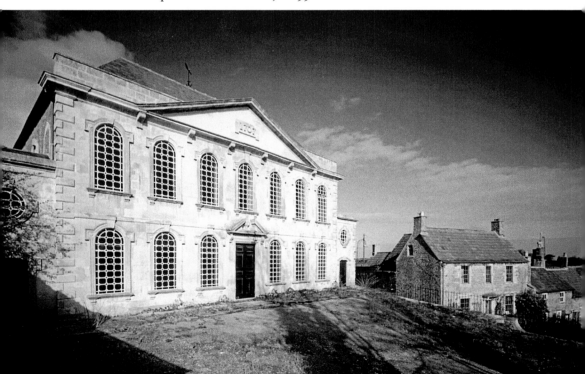

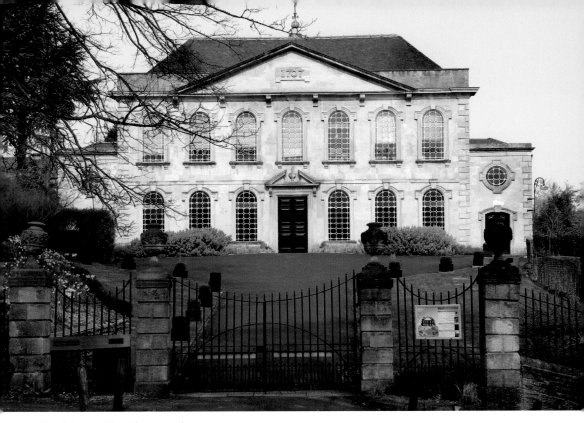

Rook Lane Chapel restored, *c.* 2005.

Rook Lane Chapel was built by James Pope for a total cost £300; probably designed by him to look like a heathen temple, but no image has survived to record this. The original building was a rectangle of 7x5 bays with two columns supporting a dome in three sections of which the centre was a cupola. The latter regularly attracted the attention of rioters in the early nineteenth century who would shout 'down with the cupola'. Before Bath Street was cut in 1812, changing the topography; the entrance must have been up steps from Rook Lane so that the chapel looked down over St John's Church. The gate piers and railings lead to a forecourt that rises to the main doorway under a broken pediment that states: 'Keep thy foot when thou goest to the house of God' (*Ecclesiastes 5.5*).

The chapel was remodelled in 1862 to a design by W. J. Stent with cast-iron windows, a new flat ceiling and additional rooms for a Sunday school behind the building.

In 1968 the congregation had declined to such an extent that the chapel was closed and the congregation went to join Zion United Reformed Church in Whittox Lane. There followed twenty-five years of unsuitable planning proposals from various developers, lack of maintenance and vandalism until it was compulsorily purchased in 1991 by Somerset County Council and transferred to the Somerset Buildings Preservation Trust, who repaired and renovated it. It was duly sold to Mendip District Council but there were no viable plans for its

use and the building deteriorated and was vandalised again. Only in 2001 was a permanent solution found with the sale to NVB Architects, who developed the mezzanine floor in the chapel and built an extension as their offices while the main hall, which retained the original twin columns, became a centre for concerts, exhibitions and lectures run by Rook Lane Arts Trust.

Rook Lane Chapel is a Grade I listed building and is arguably the finest surviving example of a Nonconformist chapel in the south-west of England.

17. The Blue House

In the 1720s, a local solicitor, James Wickham, raised the money to build the Blue House on the site of an earlier almshouse which had been given to the to the town by the lord of the manor, William Leversedge, in the fifteenth century. The central section formed a school for twenty boys and the two wings provided for twenty widows of the parish. These are depicted by the two statues on the front of the building, an old woman in a niche and below her and a scholar wearing a flowing bluecoat in the broken pediment of the imposing doorcase. They are recorded in

The Blue House, *c.* 2020.

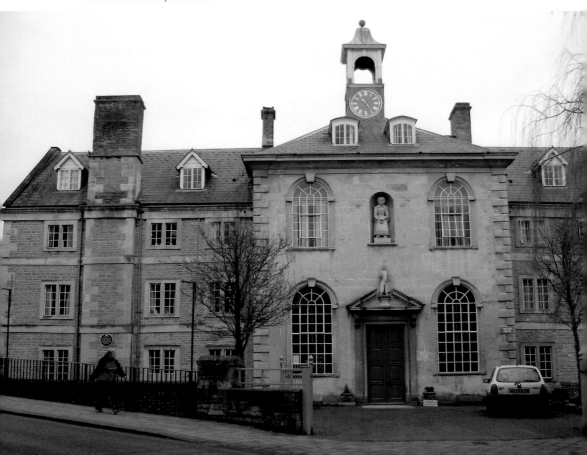

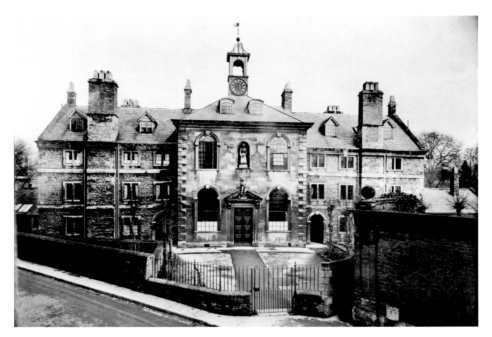

The Blue House, *c.* 1960.

the Frome ditty: 'Nancy Guy and Billy Ball up against the Blue School wall, the clock strikes one, they all go home.' The building cost £1401 8*s* 9*d* and may have been designed by James Wickham himself.

The central section of two storeys, crowned with a cupola and clock turret, is faced in ashlar in a baroque style with four large windows and an imposing main entrance with double doorway; each wing has three bays in rubble stone and is set back from the central section, their line broken by heavy chimney stacks.

There is a pair of statues, the 'Charity Girls', which flanked the main entrance of Stevens' Asylum in Keyford and were rescued when it was demolished in 1956.

The school specialised in teaching the boys to work as printers and many were apprenticed to the local trades. The school was closed in 1921 when the boys moved to Frome Grammar School and the whole of the Blue House was converted to a refuge for old people. There were plans to demolish the building in the 1960s; however, an appeal for funds to modernise the flats and maintain the building was successful. Further appeals have been made to improve the conditions and comfort of the pensioners, so that the Blue House continues its original purpose from the Middle Ages as an independent charity now run by local trustees. Its position next to the Market Place and town bridge has ensured that both pensioners and pupils have remained at the centre of Frome's activities for over 300 years. In addition to the magnificent building there is a delightful garden hidden to the east, behind the house, where the 'Charity Girls' are displayed.

The Blue House is listed Grade I.

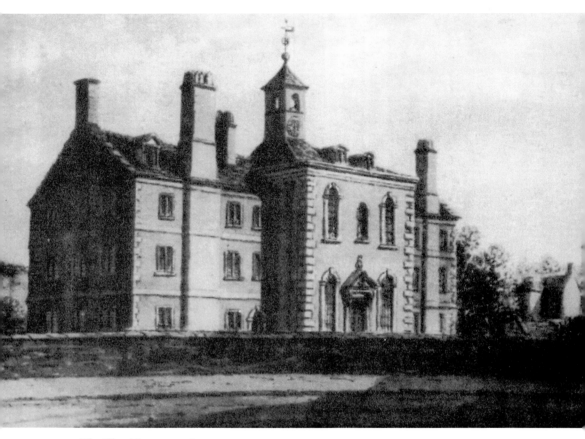

The Blue House, *c.* 1820.

18. Bishop Ken's Sepulchre, St John's Churchyard

Thomas Ken was the saintly Bishop of Bath and Wells who had sworn allegiance to James II, refused to read the Declaration of Indulgence in 1687 and, two years later, when the authority and allegiance was passed from James to William III, Ken was among the twelve bishops, known as the non-jurors, who objected. He would not abandon his principles and did not swear allegiance to William. In due course he was deprived of his see in 1691 and left the House of Lords forever. He was only fifty-four and was then given shelter at Longleat by his contemporary at Oxford, Lord Weymouth. He lived for a further twenty years until his death in 1711. He chose to be buried in the nearest churchyard of his former diocese, which was to the east of the chancel in St John's Church. Ironically, Bishop Kidder, his successor at Bath and Wells, was killed when part of the Bishop's Palace collapsed during a major storm in 1704. Ken's grave is a coffin shaped skeletal iron grating, which was later protected in 1848 by a simple canopy to form a mausoleum together with Minton tiles that show Ken's monogram, bishop's mitre and crozier,

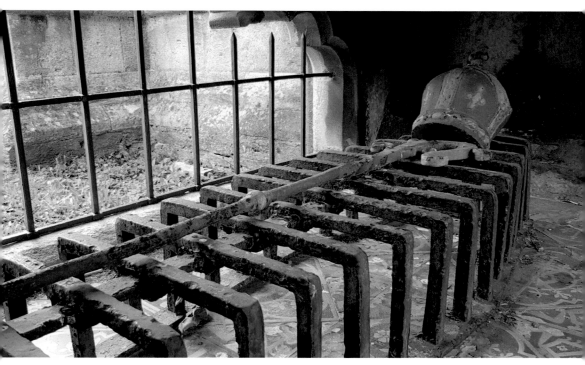

Bishop Thomas Ken's skeletal sepulchre.

and others showing coronets, Bs and Ws (Bath and Wells). His original tomb is recalled in a poem by Monckton Milnes:

Let other thoughts where'ere I roam
Ne'er from my memory cancel,
The Coffin fashion'd tomb at Froome,
That lies behind the Chancel
A basket work where bars are bent Iron instead of osier,
And shapes above which represent
A Mitre and a Crosier.
These signs of him who slumbers there
His dignity betoken:
These iron bars a heart declare
Hard bent, but never broken.
This form portrays how souls like his,
Their pride and passion quelling,
Preferred to Earth's high palaces,
This calm and narrow dwelling.

Bishop Ken's tomb is listed Grade II.

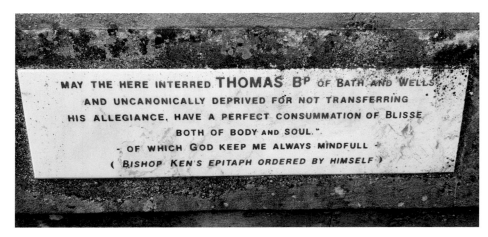

Plaque on Bishop Ken's tomb.

19. Sheppards Barton

John Sheppard bought a plot of land including 'a little tyled house' (which was later rebuilt and extended to become Wine Street House) for £22 10s in 1650 from John Champneys of Orchardleigh. He was a cardboard maker; that is he made wooden boards on which teasels were mounted for carding wool. He and his successors then developed the area of Wine Street, High Street and Sheppards Barton. The barton, itself, stands on land originally leased from the Champneys family in 1642, which had earlier been the site of St Katherine's Chantry. There are still vestiges of medieval structure within some of the buildings on Catherine Hill.

Sheppards Barton to the south-east.

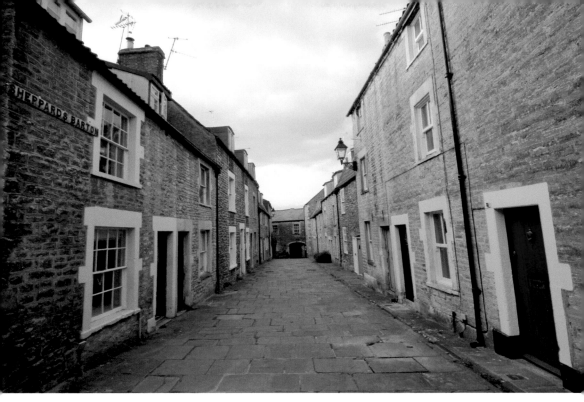

Sheppards Barton to the north-west.

There had been a path leading up from No. 13 Catherine Hill on the left of the steps to Behind Town (Christchurch Street). During the eighteenth century the terrace of cottages was developed by the Sheppards on the south side with tenements and workshops opposite. The workshops were converted to housing during the 1820s when Sheppards Mill in Spring Gardens was constructed and employed several hundred workers, so there was no longer a need for home weaving as that work was now concentrated in several mills owned by the Sheppards.

'Old Manse' was conveyed by William Sheppard to the trustees of Sheppards Barton Baptist Chapel in 1790 and stands at the top of the barton. The Sheppards were Baptists and land at the top of what was then Sheppards Barton (now South Parade) was given to both the Society of Friends for the Quaker chapel in 1675, where they constructed their first meeting hall and for the first Baptist chapel in Frome.

The Sheppard family were the most important clothiers and mill owners in Frome who, as Baptists, gave the two Baptist chapels in Sheppards Barton (1708) and Badcox Lane (1711). Many of the family later became Anglicans, the most famous of whom was Revd David Sheppard, test cricketer and later Bishop of Liverpool.

Today Sheppards Barton shows the development that has taken place over the past 250 years to become one of the most intriguing streets in Frome with the individual differences of the houses with their separate identity, combining to make an important group of vernacular housing, all of which are listed Grade II.

Sheppards Barton archway and steps to Catherine Hill.

2c. Catherine Hill House

Catherine Hill House was built by George Whitchurch in around 1715 next to Badcox Lane Baptist Church and it remained in the Whitchurch family for a century. It has a fine five-bay Georgian façade with a stone pediment surround and Doric columns to the front door with access from Catherine Street from a series of steps. There are two storeys of coursed rubble construction with parapet, moulded cornice, mansard pantile roof and rusticated quoins; there is an elegant bay to the south-west façade which was a Victorian addition.

Unfortunately, much of the fine panelling and other woodwork was destroyed when Frome Urban District Council followed by Mendip District Council leased the building in the 1960s and 1970s when the house was subdivided. From the late nineteenth century, it was home for many years to John Bell and his successors who were the main photographers in Frome.

A letter in the *Somerset Standard* in 1996 recalled an event early in the 1960s; there was a peculiar discovery by a customer from the shop in Catherine Street, when she went up to the house to get some details. When she reached the steps to the main entrance door, she recoiled in horror and going further up she said that she could feel some great evil had taken place on that spot, which involved a 'dark-skinned person'. Members of the Frome Society for Local Study then investigated

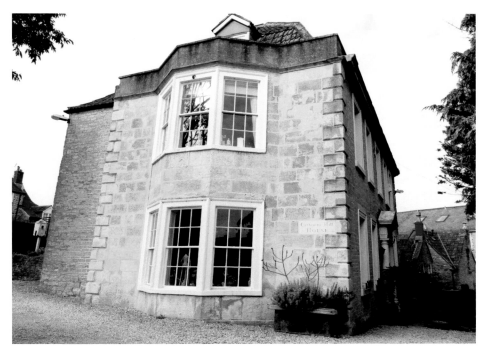

Catherine Hill House, east elevation.

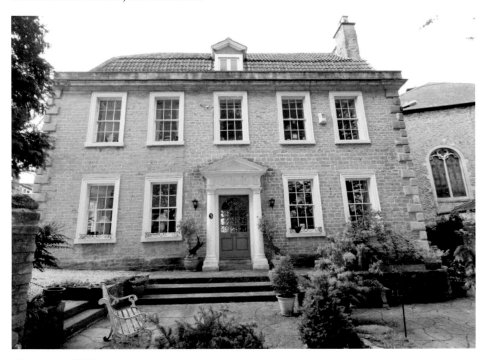

Catherine Hill House, north elevation.

the cellars under the house, which would have been the servants' quarters, but now contained stacked photographic plates from Bell's studio on a sheltered sandy floor. After digging down a few inches, a flat paving stone was revealed; when removed this gave access to a stone lined tunnel which was large enough to walk along when hunched. The tunnel led about 40 yards south where it was blocked by High Street and a few yards north where it ended in the direction of Whittox Lane, the natural course towards the river. This tunnel has later been traced to Badcox to the north and was probably an ancient drain channel.

Catherine Hill House was constructed later than some of the neighbouring buildings; there are older foundations aligned with the drains rather than the more modern walls, however, the phenomenon of the 'dark skinned person' remains a mystery and the last two owners have not encountered any ghostly happenings. Catherine Hill House is listed Grade II.

21. Frome Vicarage

The Vicarage was built by Revd Lionel Seaman, who was also lord of the manor of Frome, the lordship having passed from the Leversedge family via his mother after more than ten generations of Leversedges. He had the existing vicarage demolished and replaced with the current building. Dr Seaman had engaged

Former Frome Vicarage from Vicarage Street.

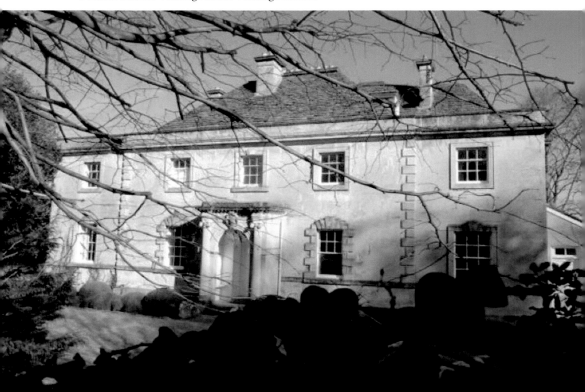

Nathaniel Ireson to restore St John's Church, however, his recommendation was that the church building was so derelict and in such a poor structural state that it should be demolished, and a completely new church built in its place. This solution was not acceptable to the churchwardens, and it is thought that Ireson received the commission to design the new vicarage in compensation.

The old Vicarage is one of the finest buildings in Frome and has several characteristic items typical of Ireson's style, such as the multiple keystones and quoinlike (Gibbsian) window surrounds. It dates from 1744 to 1749 and was built on the foundations of the previous vicarage. Although it has been altered considerably, since Revd John Skinner, vicar of Camerton, sketched the building in 1822. There is a delightful coach house beside the vicarage that appears to be older, possibly having belonged to the original vicarage. The quirky roofscape as seen from Church Street is one of the most original views in Frome. On its completion, the new vicarage was greeted in style by Dr Samuel Bowden as follows:

> A finish'd fabric now salutes the day,
> With pleasing pomp magnificently gay,
> Where yawning arches nodded all around,
> The fair creation rises from the ground;
> In graceful elegance attracts the sight,
> Smiles o'er the ruins, and dispels the night.

Vicarage stables from Church Street.

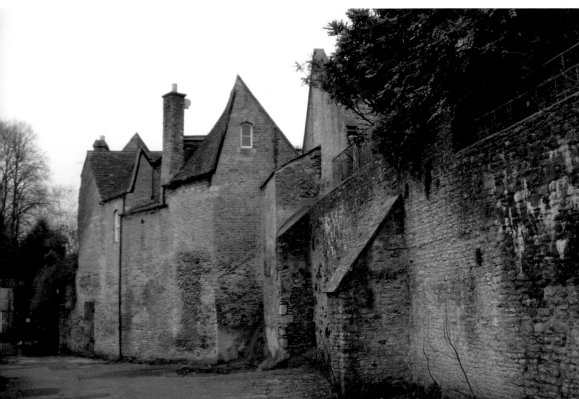

The building sketched by Skinner has been altered fundamentally. When Revd W. J. E. Bennett became vicar of Frome in 1852 and transformed St John's Church, he added wings on both sides of the Vicarage repeating the original style in addition to adding on his own personal chapel. The building now has three bays plus the two wings with an ashlar front and nineteenth-century porch with Ionic columns.

The Vicarage is listed Grade II*.

22. Ship Inn (later Olive Tree, then Artisan)

The Ship was one of the oldest pubs in Frome, predating the development of 'New Town', the Trinity area, in the late seventeenth century. The original building was a simple square block, built by the Leversedge family, as lords of the manor. Conveniently placed in Badcox as shown on the 1774 map, it was probably built at the beginning of the seventeenth century. In 1766, William Butler was the tenant of the 'Ship' under the estate of 'the late Revd Dr Seaman' who had inherited the title and lands of the Leversedge family but had died in 1760. Butler later bought the freehold at auction in 1780. The Cruse map of 1813 shows that a house has

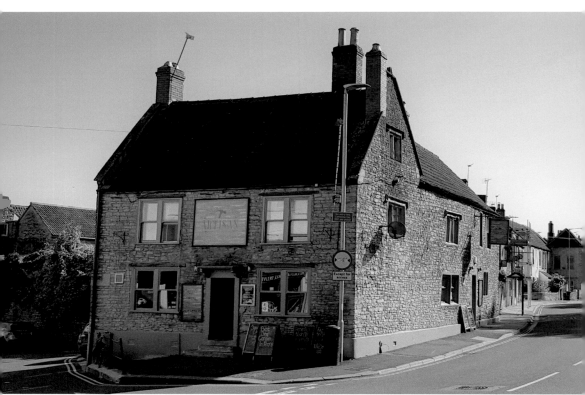

Former Ship Inn (Artisan in 2020), Badcox.

been incorporated along Behind Town (now Christchurch Street West). It was at the top of Badcox Lane (now Catherine Street) and, being close to the housing developments of Sheppards Barton, Wine and High Street on the one hand and the Trinity area, was well placed as a house of ill repute and unruly behaviour for at least two centuries. Indeed, Constable Isaac Gregory, in his diary of November 1817, reports how he was called to the Ship because a man dared all comers to fight him, only to find that he had been robbed of his wallet in the meantime! Sixty years later, the landlady was accused of running a disorderly house, but the case was dismissed. More recently, the pub was completely refurbished, and, to match this for some odd reason, the name, that had been known in Frome for 300 years, was changed to the Olive Tree. Further changes to the house were recently marked by another change of name to the Artisan in 2015.

The Grade II listing reports that the 'building appears to comprise an amalgam of at least three sixteenth and seventeenth century structures based around a late-mediaeval free-standing chimney stack. Significant amounts of early fabric survive in the upper parts of the structure'. The building is rubble stone under a slate roof with modern brick chimneys. The front has two paired sash windows in moulded surrounds with central door with brackets to a stone hood. The gable facing Christchurch Street West has a two light mullion window and the extension has two and three light mullion windows.

The Ship Inn is listed Grade II.

23. Argyll House, Gentle Street

Mary Jesser, who belonged to the family of clothiers and dyers at Welshmill, built Argyll House in 1766 on land which had belonged to the Leversedge family, lords of the manor of Frome. It is No. 12 Gentle Street, just above St John's Church. The façade is finely balanced with four magnificent Venetian windows with three lights surrounded by ashlar mouldings, which are carved to represent pilasters. The central sections are rounded and wider than the side windows and their juxtaposition is symmetrical. The wide doorway, which is approached up three steps, has a plain pediment on simple columns topped by scrolled brackets. The door itself has a cross brace typical of a number of Frome houses built or altered at the end of the eighteenth century. The rubble stonework is accentuated by the heavy freestone quoins with a stone parapet which hides part of the mansard roof.

Inside, there is a 'Chinese Chippendale' staircase constructed with open newels, mitred steps and scrolled brackets, which is unique in Frome. The Jessers were clearly up to date with the most recent fashions as shown by the design of the house and its internal proportions.

Timothy Lacey had bought Argyll House from Miss Jesser's executors, then built onto the back of Argyll House to give access directly onto Bath Street, which had been cut in 1810–14. During the later nineteenth century

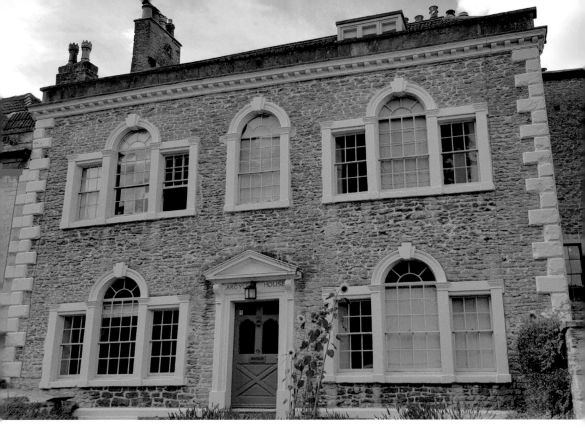

Argyll House from Gentle Street.

Argyll House became the home of solicitors and doctors. When Revd William Bennett was appointed vicar of Frome, the Duchess of Argyll, who had been a parishioner of Revd Bennett at St Barnabas' Church in Pimlico, bought the house so that she could continue to listen regularly to his sermons – hence Argyll House. During the twentieth century, the building became run down until it was rented and then bought by Norman and Lilian Maggs, who lovingly restored it and lived there for over sixty years. Norman was a pharmacist, leading town and district councillor and supporter of Wesley Chapel. Argyll House is listed Grade II*.

24. College Place (formerly Wallbridge House), Wallbridge

Wallbridge House was built at the end of the eighteenth century, one of three prominent buildings in the Robert Adam's style in Frome. It was bought by John Sinkins, the co-owner of Hapsford and Staplemead Mills. He profited greatly when the railway came to Frome by selling the land on which Frome station was built. He was probably responsible for building the two wings in the classical style, so that they conform to the central section.

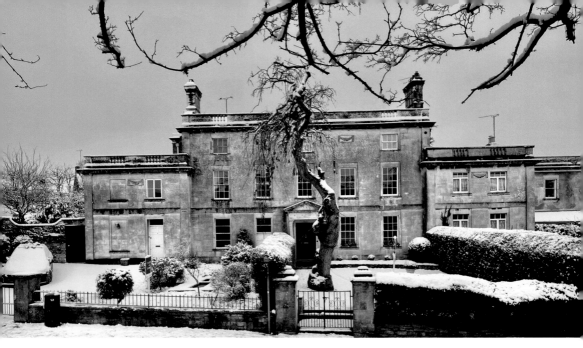

Above: Wallbridge House (College Place in 2020).

Below: Wallbridge House as St John's College, *c.* 1910.

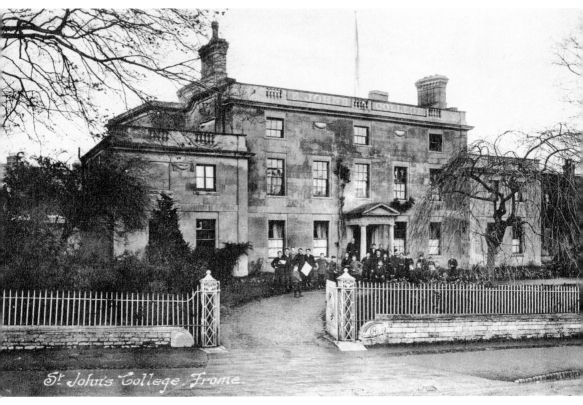

St John's College Frome.

After Sinkins' death in 1869 his widow lived on there until it was set up as St John's College, a Roman Catholic school for boys by a refugee priest who had come to Frome following persecution in France. Another French priest Fr Laurain took over from him who taught French and German there for some years.

Paton's List of Schools of 1901 states: 'The School offers to pupils the enormous advantage of acquiring French without leaving their own country ... In domestic matters the Superior has the co-operation of the French Sisters of Charity who give the boys every care and attention.' The building was extended sympathetically so that the wings integrate with the main central section of the building. It has now been altered into four separate dwellings.

25. Fromefield House, Bath Road

The Sheppards came to Frome in the sixteenth century and became the most prominent and influential mill owners and clothiers in the town. They owned Fromefield House by 1786 and when George Sheppard married in 1797, he rebuilt the existing house, which had medieval features such as former arch bracing and trucks in the roof structure, some of which are smoke blackened. He was to create

Fromefield House east elevation.

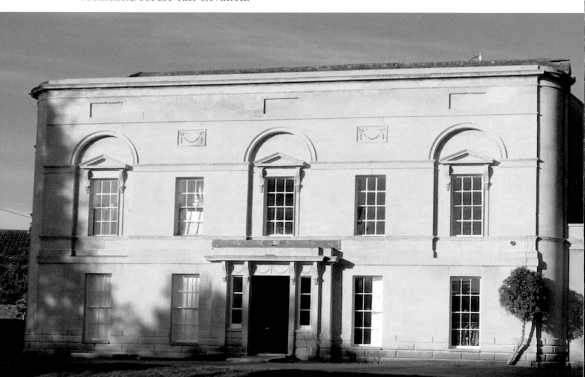

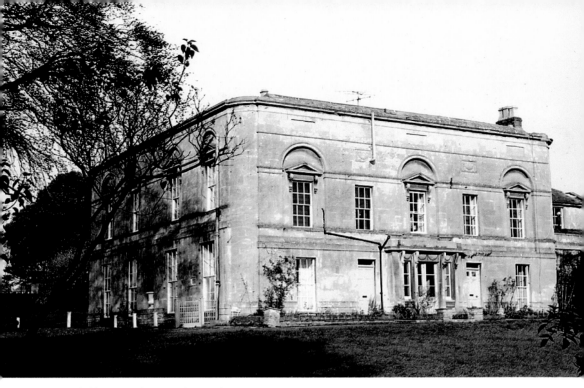

Fromefield House from Bath Road.

this most elegant adamesque house in Frome with a symmetrical ashlar front. The façade has five bays under a hipped slate roof, three bays with pediments and blind arches alternately over three windows, with remaining windows in plain reveals. The central tripartite entrance with cornice and frieze has a double doorway with plain windows to match those at first-floor level.

Fromefield was in the country and this became the largest estate in Frome, which demonstrated the wealth and social standing of the family. During landscaping of land for the garden, a long barrow was discovered and recorded by one of George Sheppard's daughters in her diary in 1820. The site of the barrow with its huge capstone has now been lost under new housing, although there are still some standing stones nearby, but they have probably been re-erected from elsewhere.

There was a spring which provided a water supply to the house and to a bath house, which consisted of two rooms, one for bathing with the stream running through it via a stone-lined bath and the other with a fireplace and chimney to recover after bathing! There was also an icehouse made in a cave for storing food in the summer. George Sheppard was renowned for his unstinting hospitality and it was said that his grocers' bill was even greater than Lord Cork's at Marston House.

The Sheppards had a large retinue of servants and gardeners and Mrs Sheppard built a school opposite Fromefield House for the education of their children; both buildings are listed Grade II.

Fromefield House has now been converted into flats.

26. Market House, Bridge Street

The most striking façade in Frome belongs to the bailiff's house, No. 13 Bridge Street. Although the façade dates from *c.* 1750, the house appears to have been an amalgamation of at least two earlier buildings. Until 1797 when a new access to the town centre from Bath to the north, North Parade, was cut, Bridge Street, the road out of the Market Yard led up to Welshmill Road on a steep bend; in his diary, Parson Woodford of Ansford recalls having an accident in October 1793 when a heavily laden wagon pulled by eight horses overturned and damaged the pole of his carriage. The turnpike came to Frome in 1757 in the form of the Black Dog Trust and met the parish boundary in Bridge Street opposite. This is marked by a unique milepost, listed Grade II.

 During the late nineteenth century the house was owned by Edwin Horwood who converted some of the outbuildings to his 'manufactory' for making stained glass. This was a major enterprise and Horwoods' stained glass was installed in many churches particularly throughout the West Country, as well as being exported abroad.

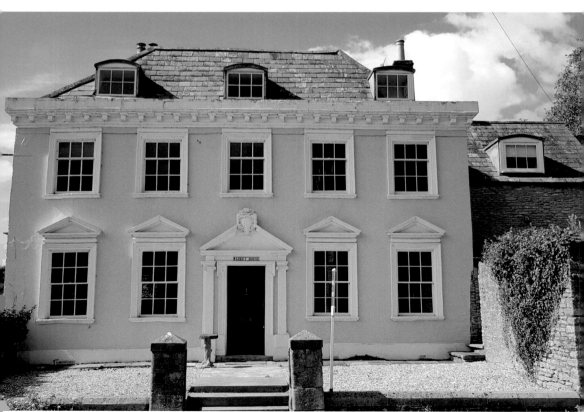

Market House from Bridge Street.

The magnificent Georgian façade has five bays and two storeys; the door frame has moulded ears and there are Ionic pilasters and an open pediment. The four tall windows on the ground floor have pediments. There are three dormers, of which the most northerly has both east and north facing windows; the latter looks over the route descending into the Market Yard so that the bailiff could check and charge tolls on goods and animals coming to town.

In the second half of the twentieth century, the outbuildings including the stables have been sympathetically incorporated into the house; the very fine roof structure records many of the changes that have taken place to the building over the years.

The house is listed Grade II*.

27. North Hill House, North Parade

This late eighteenth-century house was built in 1763 just before the Robert Adam style reached Frome. It has a commanding position overlooking the town centre and was designed by William Jesser, a member of the family that owned the mill and dyehouse at Welshmill, for a mercer, Timothy Lacey, who, in turn, had just married Eleanor Sheppard. This fine building, faced in ashlar, has seven bays;

North Hill House from North Parade.

unfortunately, an attic storey was added in the early nineteenth century, which destroys the original balance of the design, when it was owned by the Wickham family, who were solicitors in Frome for over 200 years. Later owners were the two Philip Le Gros, father and son, who, together with the Thompson family, owned and ran the Silk Mill in Merchants Barton. Their descendants, including the romantic novelist Betty Trask continued to live there until 1955 when the house was bought by Frome Urban District Council (UDC) to house their offices. With local government reorganisation in 1974, Frome UDC was adsorbed into Mendip District Council, who continued to use North Hill House for offices until brand new buildings were created in Shepton Mallet after which the offices were moved there. After serving as commercial offices for the Milk Marketing Board, then Arla, a Danish Milk Marketing Company, North Hill House has become a centre for teaching children with additional needs.

The façade is divided into three sections with the central section set back with a doorway surrounded by Ionic pilasters and surmounted by a simple pediment. The mansard roof is in slate and has five dormers.

To the east and west there were superb gardens, both in front and behind the building, until the freight railway from Radstock cut off the east section in 1854, leaving a delightful summer house on the far side of the railway line, which runs in a cutting. This building, sometimes designated as an icehouse, has a similar style to the original North Hill House before the additional storey was added. There are also two fine buildings to the north which used to be the stable cottage and coach house.

North Hill House is listed Grade II.

28. Lamb and Fountain Inn, Castle Street

The Lamb and Fountain is one of ten pubs that survive in 2022 from the forty-one that appear on the 1774 map of Frome. It is on the edge of the Trinity area and gave its name to Fountain Lane on which it stands (now Castle Street). The building dates from the late seventeenth or early eighteenth century. The listing schedule describes it as a 'L-shaped plan consisting of the main two and a half storey block fronting onto Castle Street with cellars below'. Attached is an eighteenth-century north-east range of double depth and a cross wing aligned north-west to south-east.

The principal façade has three light windows to each gable end with hood moulds to both ground floor openings and to the first-floor window in the left-hand gable. The main entrance is in the left-hand gable with a studded door from *c.* 1700. To the north-east the eighteenth-century range is one and a half storeys with basement and irregular fenestration and doorways. Walls are of local rubble stone under pantile roofs.

An unusual feature of the pub is that there was an underground floor maltings in the most northerly building where there is an access hatch for loading sacks

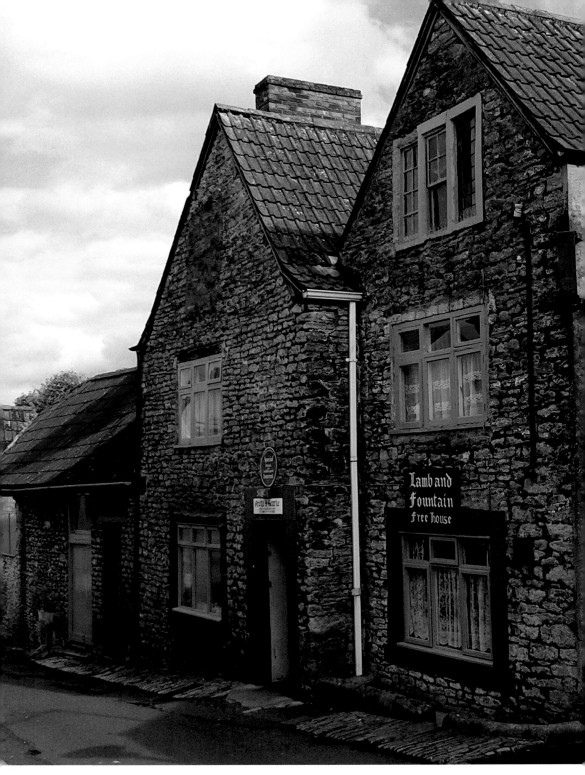

Lamb and Fountain Inn, Castle Street.

of grain and malt under the eaves in the gable. This probably replaced earlier malting floors in the cellars, but would have used the original kiln, which dated from the early eighteenth century, although there are no longer any remains of the chimney or cowl. The cellars used to lead into a tunnel to the brewhouse on the opposite side of the road, as shown on the 1886 OS map of the town; there is a brick icehouse built as a cup and dome structure, which may date from the first construction of the building. In addition to the cellars there are tunnels which run in different directions under the building. This pub retains many original internal features and is a fine example of a simple inn that has served the locality over more than three centuries. Since 1969 this has been thanks to Freda Searle, who until her death in late 2021 was the longest serving landlady in the United Kingdom.

The inn is listed Grade II.

29. Round Tower, Justice Lane

There are few clear reminders of the weaving industry left in Frome apart from the magnificent clothiers houses and the terraces of weavers' cottages. However, the most prominent is the drying stove at Justice Lane in the Market Yard, which

Round Tower, *c.* 1980.

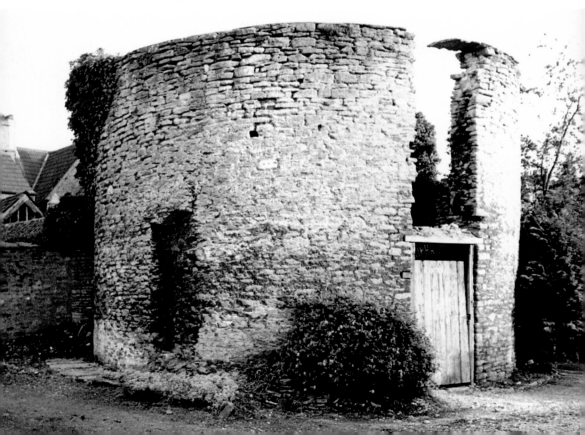

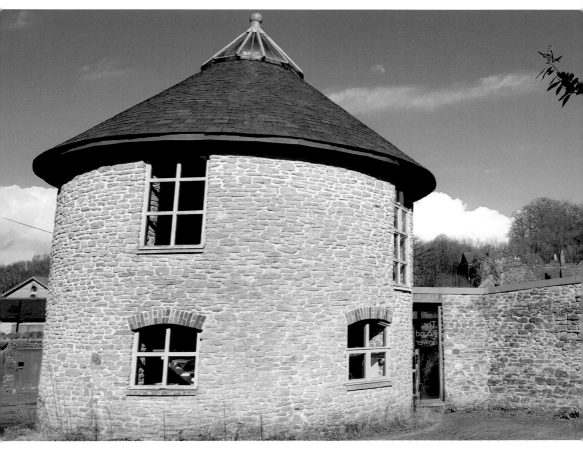

Round Tower restored, *c.* 1990.

is one of twelve towers that had belonged to the Olive family. When wool had been scoured to remove the lanolin and to wash it clean, it had to be dried for carding or before being dyed, if it was to be 'dyed in the wool'. Drying houses were normally stone built, about 5 metres in diameter with two storeys, which contained a heating stove with steel chimney and a series of slatted floors and slatted roofs to provide ventilation for water vapour and steam to escape. It was no longer in use and had become a stable owned by Francis Brown by 1873. This example was derelict for many years, but has now been renovated and converted to a gallery and exhibition centre with a fine conical roof and forms part of the Black Swan Arts complex; earlier it served as the first permanent Frome Tourist Information Centre, which was ideal as an attractive invitation for visitors to Frome to appreciate the history of the town.

There is another drying tower, lying derelict in 2021, in a garden off Willow Vale, which remains as a record of the dyeing industry in this part of town.

The Round Tower is listed Grade II.

30. The George Hotel, Market Place

The George was owned by the Leversedge family as lords of the manor and has been the most important Frome inn since the Middle Ages. The first written reference dates from 1650 when Sir John Horner of Mells and Mr Barnfield of Hardington met there as magistrates when their lunch cost 16 shillings, was paid by the churchwardens. The George passed to Revd Lionel Seaman as the last lord of the manor, before the Boyle family in 1751. It was then that the Earl of Orrery rebuilt and restored the inn magnificently for £426 4s 10d, before being let to John King, where he remained for four years. There were a series of landlords until 1794 when John Hooper took over for sixteen years during which the George became the centre of the Frome Military Association. The hotel then became the popular venue for the volunteer cavalry and infantry.

A market hall in the Grecian style with Ionic columns and pilasters below a frieze and cornice was built in 1830 with Assembly Rooms above, which had

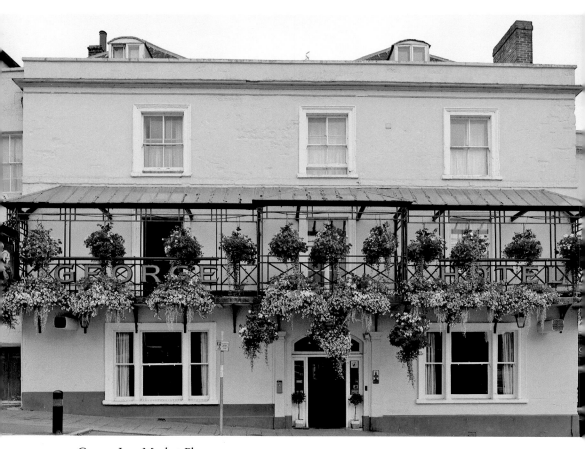

George Inn, Market Place.

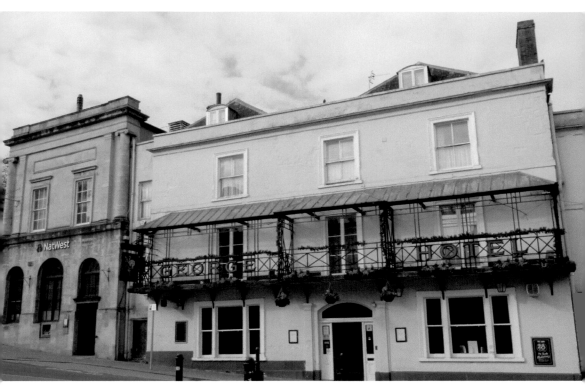

George Inn with former Assembly Rooms (now NatWest Bank).

convenient access from the first floor of the George. The Assembly Rooms. were acquired by the NatWest bank in the 1970s. Although the George has a Georgian façade , in fact it was rebuilt completely by the 9th Earl of Cork in 1874 with a main entrance surrounded by two columns that were destroyed when a runaway wagon ran into them in 1916.

The George has always been prominent in the life of the town; it was where the banquet to celebrate the coronation of George IV was held. In 1832, Frome elected an MP for the first time; the two contenders were the Whig Thomas Sheppard and Tory Sir Thomas Champneys, whose supporters used the George as their headquarters. When Sheppard was declared the winner of the election, Champneys' supporters attacked those of Sheppard who retired into the George. The riot continued with the Liberals throwing stones from the windows at the opposition from the protection of the hotel. At other times, the balcony was used for pre-election speeches from the candidates, as well as the declaration of the results. This led to a further riot in 1854. The declaration of the result was later moved to the new police station in Christchurch Street West, built in 1857, perhaps better located to halt any further riots ...

The George Hotel is listed Grade II.

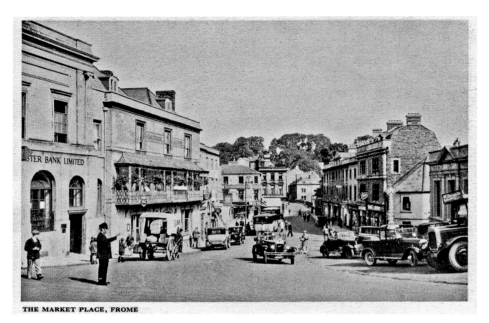

THE MARKET PLACE, FROME

George Inn and Market Place, *c.* 1925.

31. Zion Congregational Chapel, Whittox Lane

A group of Calvinist Methodists broke away from the Wesleyan Methodists in the 1770s to form a new congregation, which took over a small Zion Chapel in 'Little Sion' used by some Moravians. Pastors were supplied from Lady Huntingdon's Connexion in Bath until the congregation chose their own minister. The present chapel was built with pedestrian access from Whittox Lane and Chapel Barton and was opened in 1810. Various improvements were made during the nineteenth century: a large school room was added behind the chapel; cottages in Whittox Lane and Chapel Barton were demolished to create a cemetery and secondary access from Catherine Hill ; a beautiful octagonal infants' school, probably designed by Joseph Chapman Jr, was given by Mary and Joseph Tanner in 1875; and finally an Italianate facade was designed and built by Joseph Chapman Jr in 1888, which replaced the dour southern front facing Whittox Lane.

Although the congregation had increased after the closure of Rook Lane Chapel in 1968, the last service was held in 2014 and the building sold. It has now been sympathetically restored and has become a successful bakery, café and community space, which is particularly popular with young mothers and their children.

This is the only chapel in Frome that has retained its original galleries together with the fine screen balustrades by J. W. Singer of Frome, together with a superb organ.

Many of the major industrialists of the latter part of the nineteenth century who influenced the town worshipped here and they also represented a large proportion

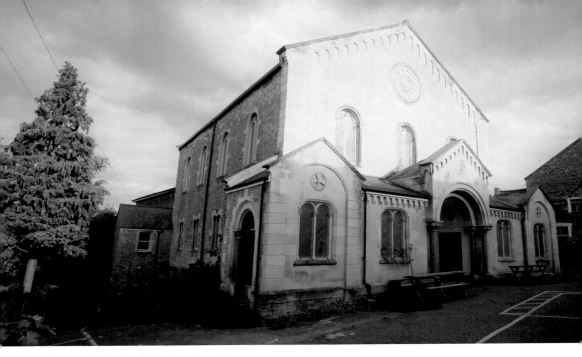

Above: Zion Chapel from Whittox Lane.

Below: Detail of archway leading via Chapel Barton to Zion Chapel.

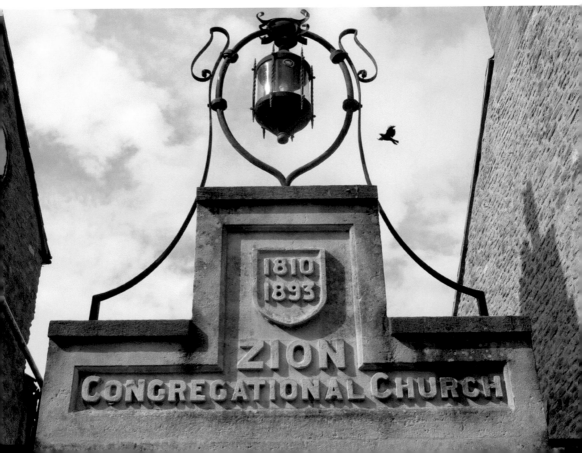

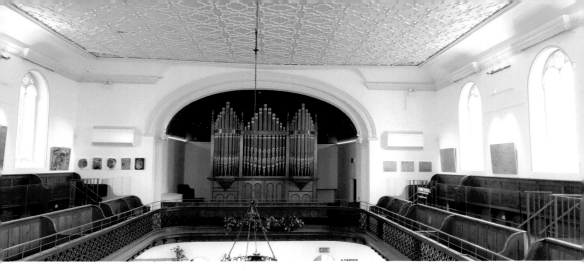

Above: Zion Chapel interior with organ.

Below: Zion Chapel interior showing mezzanine floor and balustrade.

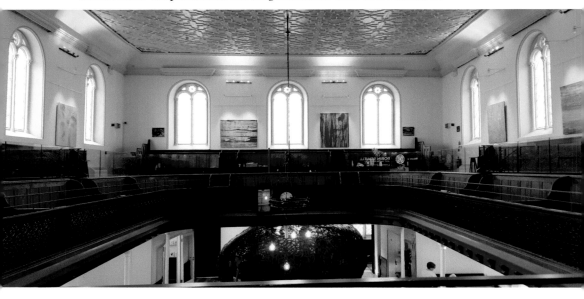

of the members of the first Frome Urban District Council: John Sinkins, the joint owner of Hapsford and Staplemead Mills, who helped to bring the railway to Frome and gave the Scientific and Literary Institution to the town; the Rawlings brothers, owners of the carding factory in Christchurch Street West; Philip LeGros, father and son, and Samuel Thompson, owners of the Silk Mill; William Butler and Joseph Tanner of the Selwood printing works; Edward Flatman, who ran a successful school in Keyford and gave the clock to Frome Town Hall; Joseph Chapman Jr; William Brett Harvey, an influential pharmacist; and Alfred Rowland, a prominent Congregationalist and sometime minister.

Zion Congregational Chapel is listed Grade II.

32. Wesley Chapel, Butts Hill

Charles Wesley first came to preach in the open air in Frome in 1752 and John Wesley came a year later; he visited and preached many times in Frome over a period of nearly forty years in the late eighteenth century. In 1761 a small congregation was formed with more than seventy members who met in Broadway; later the Methodist Society moved to 'Behind Town' where there was accommodation for 200 people. After his first visit, John found the town 'a dry, barren miserable kind of place' until he wrote in 1788: 'at length this wilderness, too, as it has long appeared to be, begins to blossom and bud as the rose, and after his last visit in September 1789: I preached at Frome to a large audience and with much of the presence of God.'

In 1779 a simple chapel was built on Golden Knoll, the site of the current chapel, that could hold 420 people but the treasurer absconded with the funds and it was only due to the intervention of John Wesley himself that the chapel remained Methodist. This proved to be too small and over £1,000 was raised for a new chapel, which was built and probably designed by James Lester using materials from the previous building. The new chapel opened in 1812 and underwent a major restoration in 1871. The alterations were all internal with changes to the galleries and the organ, which was placed under an archway against the rear wall;

Wesley Chapel from Wesley Slope.

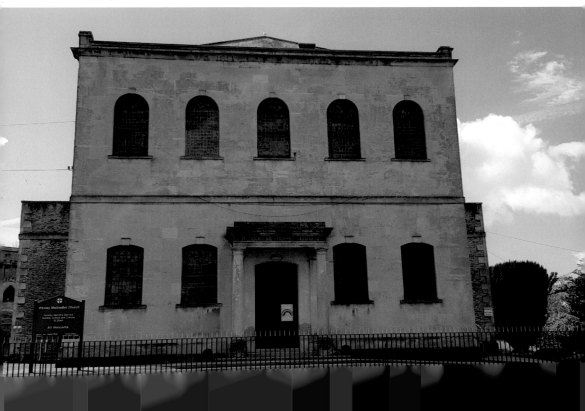

outwardly, it looked very similar to the austere building of today, almost brutalist in style. There is a plain five-bay façade in ashlar, embellished by a Tuscan porch with two columns and arched windows at first floor level and flat-roofed portico. There were further alterations to the building in the 1980s, which split the building horizontally so that the church with galleries is on the first floor, with a hall and rooms underneath.

Wesley Chapel is listed Grade II.

33. Rawlings Factory, Christchurch Street West

This building on Christchurch Street West incorporates part of the first purpose-built cloth mill away from the River Frome. It operated for about 250 years, mainly making cards for raising the nap on cloth. Originally this had been done by passing cloth through revolving drums on which dried teazles were mounted; these, in turn, were replaced by short wire-toothed combs called 'cards' mounted on blocks, which were again used to raise the nap. During the eighteenth and nineteenth centuries, Frome had become a centre of card manufacturers, with their own trade association by 1738, of which S&T Rawlings were the largest, most prosperous and longest lived, only closing in 1972. Over 500 people were

Rawlings Factory from Christchurch Street West.

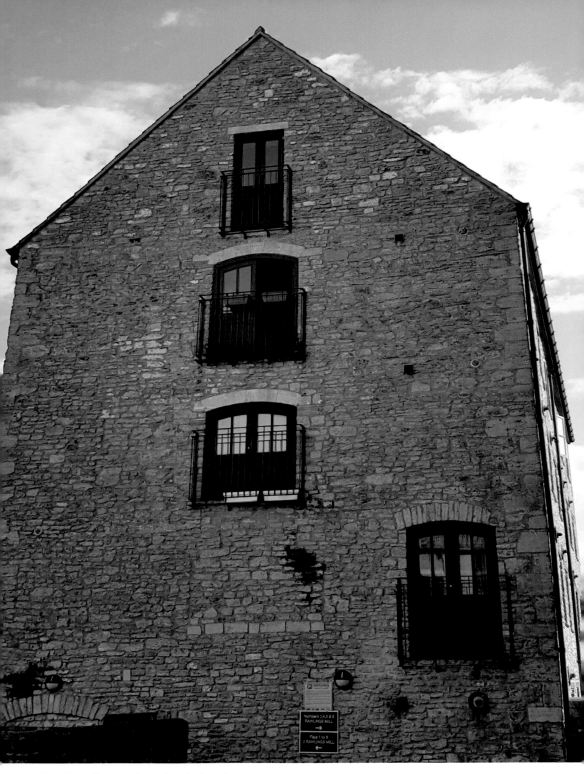

Rawlings Factory from South Parade.

employed in the various four storey buildings on the corner of South Parade and Christchurch Street West.

In the nineteenth century, the factory was using 80 miles of wire a day and later was making leather belts for driving machinery and other leather goods; Rawlings were also mill engineers. During the late nineteenth century, it was run by two brothers, Samuel and Henry Rawlings, who were inventors, entrepreneurs and pillars of the local community, becoming members of the first Frome Urban District Council when it was formed in 1894. Indeed, Samuel held a patent for a special building method to prevent fires spreading through several storeys of a factory; this was incorporated into Rawlings' premises. The brothers were also both, in turn, leaders of the Frome fire brigade.

Leather belt manufacture continued until 1972, but the buildings have now been converted to flats. Part of the original hoist can still be seen from South Parade.

34. Montgomery Court, formerly Portway Lodge

Portway Lodge was originally built *c.* 1800 and converted by Frome architect Ronald Vallis in 1934 to become the Portway Hotel. However, its main claim to fame is that Major- General Montgomery (later Field Marshall Lord Montgomery

Montgomery Court, former Portway Hotel, from Portway.

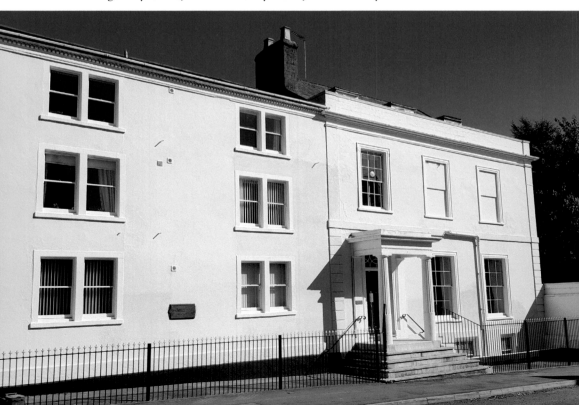

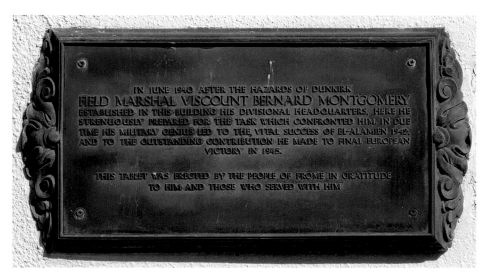

Memorial plaque to Field Marshall Montgomery on Montgomery Court.

of Alamein) made it his headquarters after his 3rd Division had retired from Dunkirk in 1940. It was here that he planned his future campaign in the desert of North Africa against Erwin Rommel.

A plaque designed by H. E. Stanton, a former head of the Frome School of Art, was cast by the Frome Metal Workers Guild and installed in May 1947. It reads as follows: 'In June 1940 after the hazards of Dunkirk Field Marshall Viscount Bernard Montgomery established in this building his divisional headquarters. Here he strenuously prepared for the task which confronted him. In due time his military genius led to the vital success of El-Alamein in 1942, and to the outstanding contribution he made to final European victory in 1945. This tablet was erected by the people of Frome in gratitude to him and those who served with him.'

After many successful years as the Portway Hotel, the building has been converted to retirement flats, called Montgomery Court, which is listed Grade II.

35. Bath Street

Until 1810, the main routes going south out of Frome were up the narrow hills of Gentle Street and Church Slope, and Rook Lane via Palmer Street and Stony Street. The former roads are steep and would have been dangerous for carriages and carts during the winter, and difficult at other times. It was due to the foresight of Frome solicitor Thomas Bunn, who wrote: 'This town was one of the worst, if not the very worst in the county of Somerset. The thoroughfares mere lanes, so narrow that carriages could not pass each other without ascending the footways … The

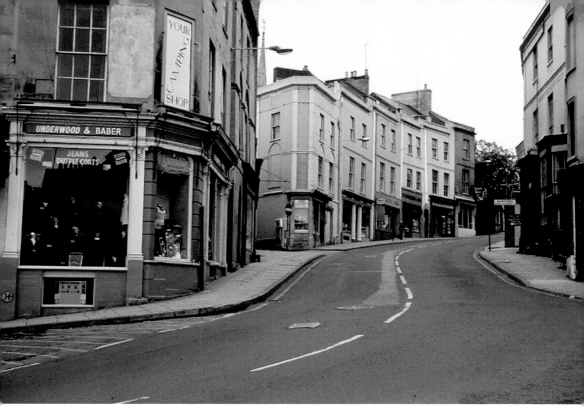

Bath Street rising from the Market Place.

streets of Bath measured, Union Street was adopted as a model for convenience, the space for the carriage road being twenty-six feet, and each footway seven feet, in the whole forty feet.'

He ensured that Bath Street rises up from the Market Place in a broad sweep that recalls Bath's classical buildings. Indeed, Bunn is said to have proposed that the alterations to the entrance to Frome from the north via North Parade, over Frome bridge to the Market Place and south via Bath Street, together with the new classical buildings that lined them, would make people refer to 'Bath near Frome' rather than 'Frome near Bath'.

Lord Bath provided the land on which Bath Street was built and the coat of arms of the Thynne family is engraved on the first-floor corner of No. 8 Bath Street that stands out to be seen as one descends from the top of the road. A new access to St John's Church was created by demolishing the Bell Inn and erecting the stone screen designed by Sir Jeffry Wyattville and carved by Joseph Chapman Sr, which leads to a fine forecourt in front of the church. Two cedars of Lebanon were planted, when the street was cut, one of which still stands serenely in the garden of one of the terrace of seventeenth-century cottages which had lined Rook Lane. These cottages have gained front gardens to access the street.

Bath Street provides a broad entrance to the Market Place from the south.

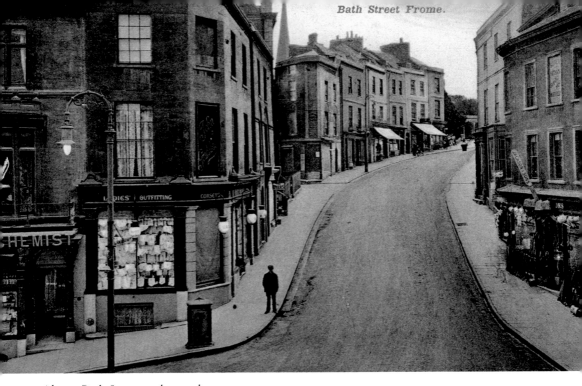

Above: Bath Street to the south, *c.* 1900.

Below: Bath Street to the north, *c.* 1900.

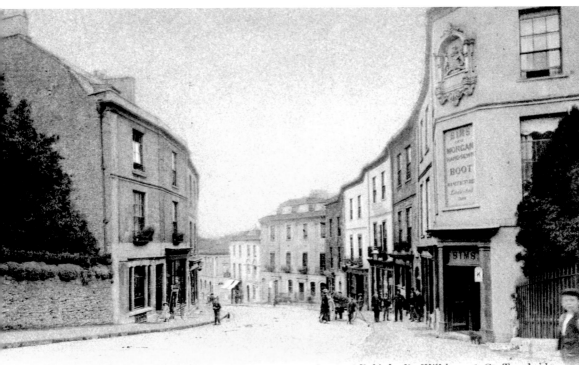

Publ. by R. Wilkinson & Cº, Trowbridge.

36. No. 20 Bath Street

The site of No. 20 Bath Street had been bought from the Longleat Estate by Frome solicitor William Whitchurch in the 1720s on which there were warehouses, houses and stables; these were acquired by the Frome Turnpike for the new main route south out of the town, which was cut in 1812. The new building which became No. 20 was erected between 1813 and 1816 in a rather bland Regency style, converted to a shop and let to a Bristol chemist and druggist, Jacob Player, as a pharmacy in 1820, which it remained for 150 years. The second pharmacist, William Langford, bought the business in 1840; he was a remarkable man whose interest in publishing and printing would have a profound effect on the future economy of Frome. He started by printing labels for medicine bottles in the Wheatsheaves Inn yard next door. This part of the business expanded with the publishing of the *Frome Almanac*, which was followed by the *Somerset and Wiltshire Journal*, which was later incorporated into the *Somerset Standard*. William Langford was joined by William Butler and the printing press transferred to Butler's shed in the yard at Castle Street House in Trinity, which, in turn, was expanded hugely to become the Selwood Printing Works, a remarkable neo-Byzantine factory in the Trinity area.

When Langford retired from the pharmacy, it was taken over by a fellow Congregationalist, William Brett Harvey, who also continued the publication of the *Journal*, although it was now printed by Butler and his new partner Joseph

No. 20 Bath Street, formerly Maggs the Chemist.

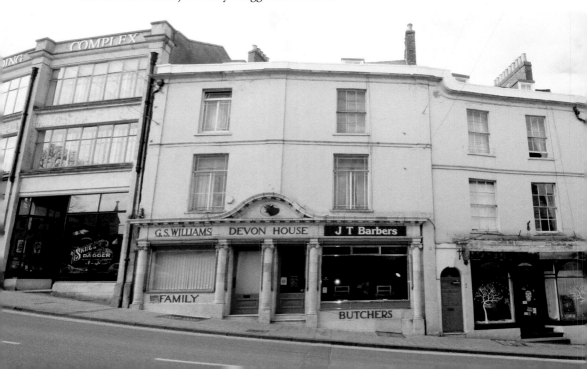

Tanner. W. B. Harvey played an important role in the town for forty years as an active Nonconformist and leader of the teetotal community, editing the *Journal* with his strong liberal views. In addition he was an original pharmacist inventing various pills and elixirs for diverse illnesses. After he retired in 1900, the pharmacy was run by two chemists before it passed to Norman Maggs, who became a noted benefactor to Frome, both as an independent local politician, a devoted Methodist and founder member of the Frome Society for Local Study and the Frome and District Civic Society. He and his wife Lilian ran the pharmacy for over forty years before retiring in 1972; the pharmacy passed to Michael Ellis, who finally closed it in 1976. The shop became a saddler and then belonged to the well-known Frome butchers Williams & Sons with a fine tiled shopfront. The building is listed Grade II.

37. Christ Church

During the first twenty years of the nineteenth century, the population of Frome had increased by 50 per cent to *c.* 11,000, mainly the working poor. Several Nonconformist chapels had been built during the eighteenth century and the Anglican church recognised the need to build a second church since St John's only had pews for 1,640, most of which were rented to named families. Sir Thomas Champneys gave the land on Pack Horse Ground for the construction of Christ Church. It was here that John Wesley had preached to large crowds on several occasions during the late eighteenth century. The County Surveyor, George Underwood, designed a simple cruciform Gothic church with a tower at the east end, which was built in 1817–18 for £3,700 and the first service was held on 15 September 1818. The building consisted of nave, north and south aisles and an eastern tower. Unfortunately, the quality of the building work was inadequate to withstand the weather in that exposed position and by 1845 structural repairs were necessary to a design by Manners and Gill of Bath. The north aisle was extended and windows enlarged to give more light into the church.

To celebrate the silver jubilee in 1868, the choir gallery was demolished and the choir moved to the chancel where they were under the eye of the vicar during the service. Thirty years later the south transept was built and over the next ten years Sir Harold Brakspear reintroduced the choir gallery and the eastern end of the church was completed. Finally, the northern transept was finished in 1929, taking 110 years to bring the building to complete Underwood's original concept.

The nave had been extended to form the chancel and there is a fine rood by Herbert Read of Exeter, erected above the altar, which dominates the interior of the church. The figures of St John and Our Lady were removed on orders from the Chancellor of the Consistory Court at Wells in 1909 as an 'illegal ornament' and

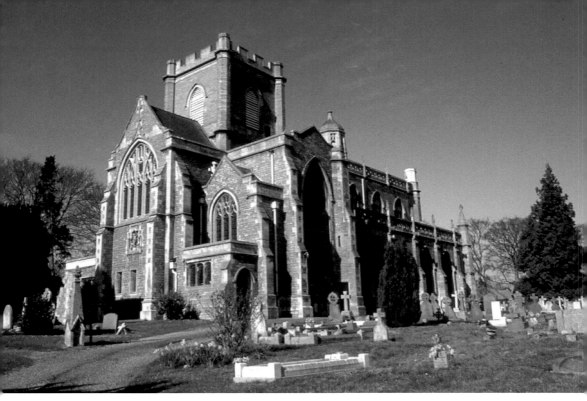

Christ Church from Christchurch Street West.

liable to 'superstitious use' and only reinstalled a few years later. They now remain to be admired in their finery.

Christ Church is listed Grade II*.

38. Brunswick Place, Nos 31–33 Fromefield

This Regency terrace, unique in Frome, was built in 1819 by Edward Pitt, a silversmith of Cheap Street. It presents a three-storey façade to the street over a basement with light wells, which was aligned with the turnpike from Bath to Frome. The current appearance probably dates from the 1850s, having a stucco façade with chamfered quoins under a hipped slate roof; each of the three houses in the terrace has its own main entrance, although only the central property has a door on the front façade, which is embellished with an elaborate glass and iron canopy porch. This creates the impression of one large house. The first-floor windows have wrought-iron balconies. The houses on north and south of the central section have entrances with similar panelled doors on the side elevations. Internally the staircases have similar details but different arrangements: the central house has a stair turret at the back with a fine entrance hall whereas the north has a side turret behind an entrance porch and that to the south is against the back wall leading off a small entrance hall.

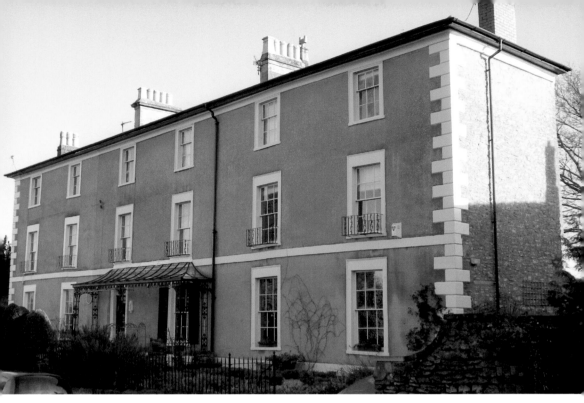

Brunswick Place, Fromefield.

The buildings were used as a school in 1850 and then modernised before Christina Rosetti, her sister Frances and their mother set up a small school in the north section in 1853; this was not a success, although it gave them the opportunity to follow Revd William Bennett at St John's Church, whom they had known in London. The Rosettis' school lasted from April 1853 to March 1854. Christina refers to Brunswick Place in her poem 'Charon' which begins: 'In my cottage by the Styx ...'

Brunswick Place was often the home of three tenants, frequently professionals, and again became a dame school where the future educationalist Clara Grant described how badly she had been taught there as a young girl; it was never mentioned that Christina Rosetti had previously lived and taught at the school there.

Brunswick Place is listed Grade II.

39. Feather Factory (Warehouse), Willow Vale

The imposing four-storey rubble stone building was either built by or for the Sheppards in the early nineteenth century. It was used by them as a workshop with large, tall, south-facing windows, which provided good light for the cloth worker, and for storage, although the long, narrow building with restricted internal

Left: Feather
Factory, derelict,
c. 1970.

Below: Feather
Factory restored –
south elevation.

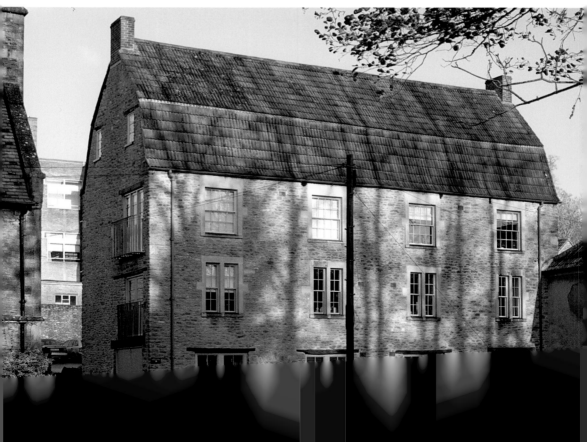

staircases must have been extremely inconvenient to work in. It was certainly owned by the Olive family for a period, although the Sheppards continued to occupy it. Frome's major builders (variously William Brown, William Brown & Sons, and F. and G. Brown) during the nineteenth century operated from this site, although it is not clear whether they used the building or only operated from workshops in the yard. These then became livery stables for twenty years as a base for taxi carriages and parcel deliveries run by the Wall family. In 1880 the building was being used to store materials for Cockeys Ironworks. During the late nineteenth and twentieth centuries, the warehouse was used for various occupations: the Grant family, who lived in No. 4 Willow Vale, repaired organs there, and J. W. Singer & Sons used it as a foundry after selling the art side of the business to Morris & Co. Later a former employee, John White, set up on his own to form the Somerset Smithy, which, in turn, operated from Christchurch Street West. The building gained its name from a period when it was used for making pillows, before becoming a depot for selling Hunter woodburning stoves and finally by Frome Reclamation after which it became completely derelict. It has now been stylishly renovated to form four apartments with external access via a turret staircase and oak landings to an inspired design by Frome architect Bruce Yoell. This has created an imposing building with clay tiled mansard roof, conveniently hiding the brutalist telephone exchange built in the 1960s from Willow Vale. However, it is visible from all the southern hills of the town. In addition to the four south-facing windows with ashlar surrounds there were ground, first and second floor loading doors to the west.

The feather factory is listed Grade II.

Feather Factory restored – north elevation.

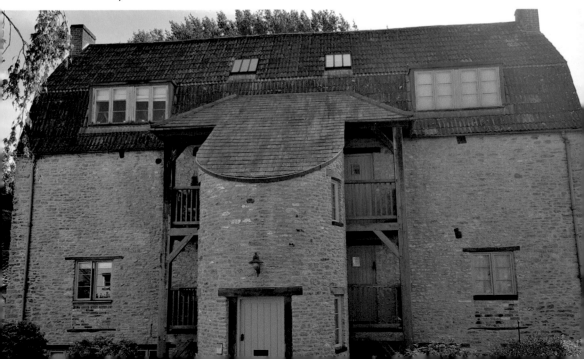

40. Apex House (formerly Conigar House), Cork Street

The Conigar area of Frome is the site of a medieval rabbit warren which was later used for growing woad, the plant that provided the blue dye used for treating woollen cloth. The Conigar, as the house was called, was built by Edward Barnard in this area in the early 1800s. This house and surrounding estate were acquired by George Messiter, an attorney at the county court, during the 1830s and he built this imposing mansion, Conigar House, on rising ground close to 'The Conigar' before 1850. It had about an acre of gardens and there were several cottages and outbuildings and a fine approach and carriage drive. Although the house was empty at the 1851 census, it was soon taken over by rich single ladies who had worshipped at St Barnabas' Church in Pimlico and followed Revd William Bennett from London, when he came to Frome. They started St John the Baptist School for orphans and poor children there, which had a strong Anglo-Catholic ethic.

Two of these selfless women, the sisters Alexandrine and Mary Ouseley, were committed to improve the lives of the poor and sick, creating an organisation of parish services that included home visits, soup kitchens, medical help and a charity shop selling clothing at low prices to the poor. Alexandrine paid for a major extension to the building to make it a home for twelve orphan girls together with a schoolroom to the south. Following the death of the sisters in 1861/62, the school was under 'Sister of Mercy'

Apex House, formerly Conigar House.

St Louis School in front of Conigar House, *c.* 1950.

Agnes Logan Stewart until 1871, and continued after her departure to Leeds until 1877. In 1880, Frederick Messiter sold the freehold to John Webb Singer and the building was rented out for several years before being taken over by a Roman Catholic order, 'The Sisters of Charity of St Louis', in 1902. The building was again used as a school but for Roman Catholic children, for which it continued for the next seventy years until reverting to J. W. Singer & Sons for their offices. The development of the building is easy to follow, the original section with double bays surrounding the simple entrance and pediment. The main extension for the school and orphanage lack the bay windows and the schoolroom, recalling a simple chapel, completes the building, which has now been converted to flats.

41. Holy Trinity Church, Trinity Street

With the strength of the Nonconformists in Frome, the Anglican Church decided to build a third church in a prominent position in New Town in 1836–37 at a cost £2,310; indeed Holy Trinity Church gave the name to New Town, the whole Trinity area, which had a population of about 4,000; they were mainly weavers many of whom were now employed in Sheppards factory in Spring

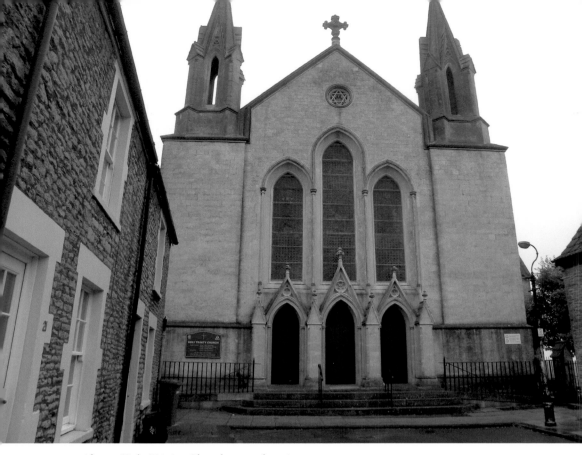

Above: Holy Trinity Church, east elevation.

Below: Holy Trinity Church, north elevation.

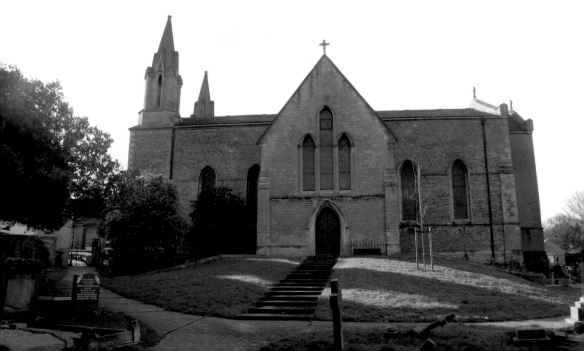

Gardens. H. E. Goodridge, the Bath architect, was given the commission to design the new church, although he is said by Thomas Bunn never to have visited the site. Probably, it was for this reason that the entrance is at the east end and the altar is in the west. The church, which dominates the approach along Trinity Street, is imposing with three broad doorways slightly elevated above the street, surmounted by three lights and the whole façade crowned by two minor spires. The interior has a high nave and reduced chancel; the nave is embellished with twelve superb stained-glass windows by Morris & Co. to designs by Edward Burne-Jones, which depict Jesus and the apostles in brilliant colours, together with one triple lancet by Horwood Brothers of Mells above the altar. There used to be a fine wrought-iron screen by J. W. Singer & Sons that originally stretched across the chancel; this has recently been cut down into three sections and placed in a side chapel, where its imposing beauty can only be imagined.

The first vicar was Revd Alfred Daniel who started his children's interest in printing, which led to his buying an Albion press. It was used to print notes and invitations for the church, which were used to attract and inform the population who lived in New Town. His eldest son, Henry, became a don at Worcester College, Oxford, where he printed some beautiful books on a larger Albion press for his colleagues including limited editions of the future poet laureate Robert Bridges.

Holy Trinity Church is listed Grade II*.

42. Vallis (formerly Milk Street) School

Vallis School was founded by the British and Foreign Schools Society, which had been started by a Quaker, Joseph Lancaster, in 1805. It was established in 1843 in the Rechabite Methodist Chapel in Milk Street, which had been built three years earlier. The latter had probably been unsuccessful since the Rechabites were strong supporters of the temperance movement, unlikely to appeal in the Trinity area, a working-class district with many pubs. Many of the first trustees attended Zion Congregational Chapel, again a pillar of temperance, only three minutes' walk away. The school expanded regularly by taking over the cottages next door. From about 220 pupils in the early twentieth century it grew to more than 600 after the First World War.

The school had two outstanding pupils: Fred Knee and Charles Oatley. The first of these was the son of wool workers, born in Blunt Street in the Trinity area in 1868, who, after attending Milk Street School, was apprenticed as a compositor at Butler and Tanner's Selwood works before leaving for London; he campaigned for workers' housing and was heavily involved in radical politics, coordinating the activities of many different organisations and becoming the first Secretary of the London Labour Party before dying of pleurisy in December 1914 when only forty-six. He was succeeded by Herbert Morrison, a future Home Secretary.

Above: Vallis, formerly Milk Street School.

Left: Memorial plaque to Fred Knee, Vallis School.

Following Knee's death, Keir Hardie wrote of him: 'I have known and respected him for over twenty years during which period he rendered devoted and faithful service to the cause of socialism and labour. We shall all miss him and mourn his loss.' Sir Charles Oatley was born in Badcox Parade in 1904, the son of a baker, and attended Milk Street School after the County Education Committee took over responsibility in 1907. He recalled his time at the school 'with great affection' and that the school 'gave him a sound, if limited, elementary education'. Sir Charles later became Professor of Electrical Engineering at Cambridge University and was one of the two great pioneers of scanning electron microscopy.

Vallis School continues as a county primary school over 175 years after its foundation.

43. TSB Bank (previously Lloyds Bank), Market Place

Willoughbys were both grocers and bankers with a fine classical building, on the corner of Cheap Street and the Market Place, probably dating from when Bath Street was cut in 1810–12. They were affected by the depression following the Napoleonic wars in the 1820s and the bank failed in 1825. The shop was incorporated into the Wilts and Dorset Bank *c.* 1840, which underwent a major refurbishment by W. J. Stent of Warminster, whose initials can be seen above the main entrance, to a design in a powerful Italianate style to give credibility to the strength of the bank. Effectively, this is the TSB Bank that one sees today, although the interior has been completely stripped and replaced. The original four storeys have been reduced to three with an attic, a projecting ground floor and circular corner with the main entrance. The whole building was faced with ashlar and embellished with Corinthian pilasters on the first and second floors. The first-floor window surrounds have cornices and dropped acanthus capitals.

TSB Bank is listed Grade II.

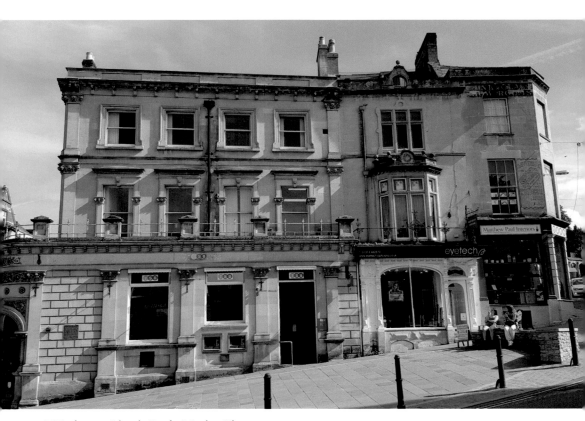

TSB, former Lloyds Bank, Market Place.

44. Frome Railway Station, Station Approach

Railway mania did not enthuse north-east Somerset and the Wiltshire, Somerset and Dorset branch line only reached Frome from Westbury in 1850. The first train arrived on 7 October to little acclaim by the people of Frome. The company had already been taken over by the Great Western Railway and there was a single broad-gauge track, which was later doubled. The station itself was out in the country equidistant from the town centre and Keyford; it was designed by T. R. Hannaford, who worked in I. K. Brunel's offices and was approved by Brunel's close associate J. H. Bertram.

The main beneficiary was John Sinkins, the owner of Wallbridge House (and subsequent donor of the Literary and Scientific Institution building to the town), who sold the land for the station to the Wiltshire, Somerset & Weymouth Railway for £1,800, having only paid a few hundred pounds for it. The station is unique in the West of England, retaining its original design of 'an overall roof' where both tracks were completely covered for trains to pass straight through. The shed is

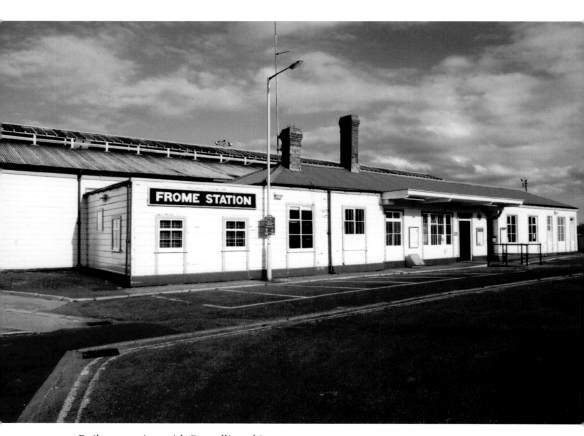

Railway station with Brunellian chimneys.

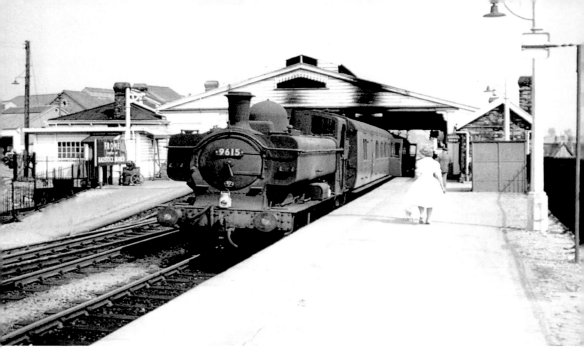

Above: Frome railway station, *c.* 1950.

Right: Memorial plaque on Frome railway station.

Frome Railway Station

Designed by T R Hannaford, an assistant to I K Brunel, and opened on 7 October 1850. This timber construction is largely unaltered and a rare example of a Brunellian through train shed still used for its original purpose. Listed Grade II.

Frome Society for Local Study and Frome and District Civic Society

timber framed with a hipped corrugated iron roof; there are single-storey offices with red-brick Brunellian chimneys on the town side. Although the building may have been planned to be temporary, with regular maintenance it has now lasted over 170 years, having been twice renovated over the past forty years.

The arrival of the railway created the opportunity of the major development of Frome during the second half of the nineteenth century with the three important industries of Butler and Tanner (printing), Cockeys (engineering) and Singers (statuary), as well as many other smaller industries, during a period of decline in cloth manufacture. Another major effect was the change in building materials, with bricks and tiles from Bridgwater replacing stone and thatch, and slate from Wales and Cornwall. This can be seen as the town expanded with the housing developments reaching towards the railway station.

Frome railway station is listed Grade II.

45. Marble Works, No. 44 Portway

Joseph Chapman Sr was the stonemason who made the stone screen, designed by Sir Jeffry Wyattville, giving access to St John's Church, when Bath Street was cut in 1812. His work was followed by his son, Joseph Chapman Jr, who had a major influence on Frome as stone mason, designer, leader of the temperance movement and member of the Frome Urban District Council. He designed No. 44 Portway to show the different styles of window tracery that his customers could choose; there was a mixture of classical and neo-Gothic to give an eclectic mix that included barley sugar twists, Ionic columns, Norman tracery, gargoyles and a gryphon, should they be required. The house dates from 1867 and provided both a home for the Chapman family of ten children and a working yard for stonemasons behind it. The building is listed Grade II.

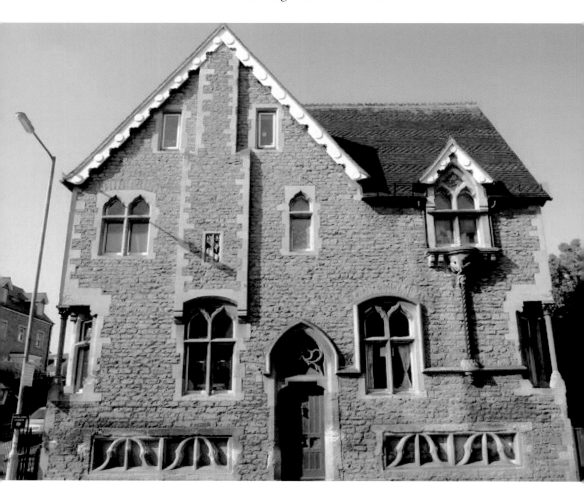

Marble works, No. 44 Portway.

Joseph Chapman Jr married the daughter of Isaac Gregory, whose diary as Constable of Frome describes the town during the Regency period relays the problems of keeping order in an unruly town at the beginning of the nineteenth century.

46. Wesley Villas, Wesley Slope

Following a disastrous fire on a Sunday in August 1858 at Golden Knoll, opposite the top of Bath Street, that destroyed three thatched cottages next to Wesley Chapel, which belonged to Thomas Bunn, the elders bought the freehold of the land and advertised for a design and plans for a series of new buildings to include two large manses, day school and headmaster's house. Although sixteen architects submitted drawings, the winner was a twenty-three-year-old architect from Bath, William Willcox. There was considerable controversy about the detailed design between the commissioning committee, but the complex was completed in 1863 at a total cost £4,082 2s 8ds. More than half of this was paid for by the estate of the Pooll family of Rode and a further quarter from the Rabbitts family of Studley, near Wanstrow, with the foundation stone being laid by William Rabbitts

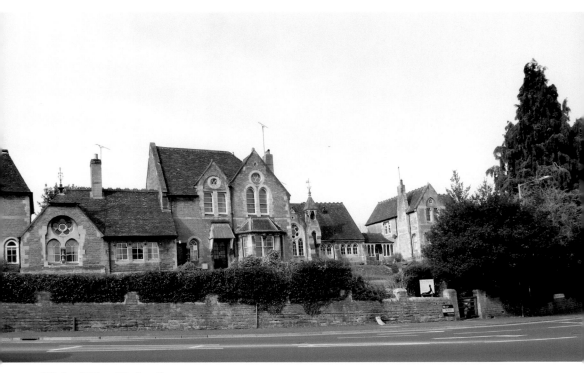

Wesley Villas, Wesley Slope.

Wesley Chapel and Buildings, Frome

Wesley Villas with Wesley Chapel, *c.* 1900.

in 1862. There were two large manses built for the minister and the wider Methodist Circuit, a Wesley boys' school and headmaster's house. These buildings have subsequently been sold or used for other purposes.

The buildings are in a simple neo-Gothic style and are superbly balanced standing as a group beside the rather stark geometry of Wesley Chapel, built in 1812; they form the most handsome block of nineteenth-century neo-Gothic buildings in Frome. They all have asymmetrical elevations and are dressed stone with ashlar dressings and quoins under tiled roofs. The boys' school and master's house are set back behind a rising lawn to break the line and the single-storey school continues the asymmetry with an unusual belfry supported by a buttress and single corbel.

Unfortunately, the growth of the gardens and trees shields the buildings so that it is difficult to appreciate them as a whole. They are best viewed from Gorehedge, the grassed slope where the Lamb Brewery used to stand.

The buildings are listed Grade II.

47. Selwood Printing Works, Selwood Road

William Langford and William Butler had moved their printing press from the Wheatsheaves yard in Bath Street to the garden of Castle Street House and, as their work expanded, the successors, Butler and Tanner, bought up cottages in

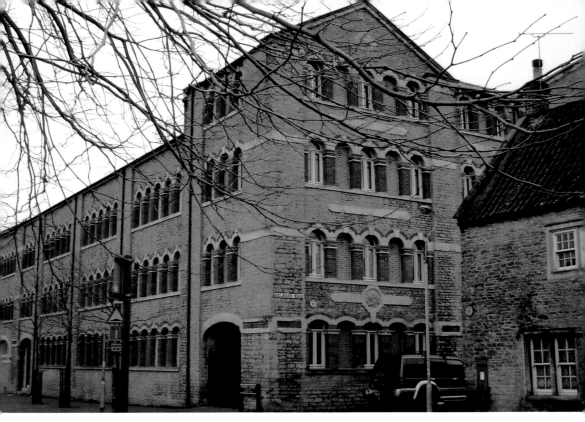

Selwood Printing Works, Trinity Street.

Trinity Street and Selwood Road so that they could build a new factory. Joseph Chapman Jr, a stonemason, builder and architectural designer, produced a neo-Byzantine building redolent of a factory in central Europe. The first section dates from 1866; this was extended regularly and the whole works were only completed in 1911. The factory was a boon to the Trinity area, which was suffering a major reduction in employment in the clothing industries, particularly with the closure of Sheppards' huge mill in Spring Gardens. The Selwood Printing Works had taken on 450 employees by 1892.

When completed, the buildings were four storeys high with basements at two levels; the machinery on the ground and first floors was driven by two steam engines. The Selwood Works continued operating when it became used for storage, until the lifts were condemned after the Second World War, since printing had been transferred to a new site at Adderwell.

With no lifts, it could no longer be operated and the building lay derelict for many years. There were advanced plans to demolish the building up to the 1990s but it has now been converted to apartments to an informed design. The fourth storey has been removed and the central section opened up to provide a safe area for children and car parking. The base of one of the chimneys can be seen next to the engine house in the central yard.

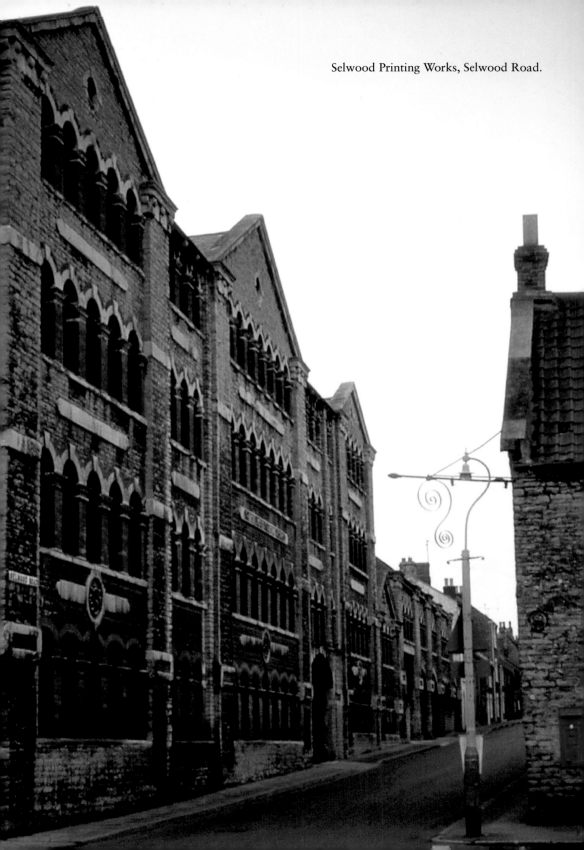

Selwood Printing Works, Selwood Road.

48. Frome Museum, formerly Literary and Scientific Institution, North Parade

This Grade II listed building, prominent between North Parade and Bridge Street and next to Frome bridge, was built for £3,000 by John Sinkins, a wealthy clothier, who gave it to the town in 1869 to be the new home of the Literary and Scientific Institution. The architect was James Hine of Plymouth, who designed an Italianate building with ashlar facing on a very difficult flat iron site with varying levels of access. There are three storeys to the wedge-shaped block with heavily moulded strings. His concept of a grand liner sailing into port can well be imagined when looking up North Parade from Frome bridge. The impression is emphasised by the rounded Venetian windows and the balconies that adorn the east side of the building facing North Parade. The west side facing the former market yard is quite simple. Inside the building in the apex of the wedge, there is a magnificent cantilevered staircase with cast-iron balustrade, by Singers of Frome, which winds up three and a half storeys.

The Lit, as it was known, had been founded in 1844 and was the meeting place for the great and the good of Frome. It had a library and small museum

Frome Museum, former Literary and Scientific Institution, North Parade.

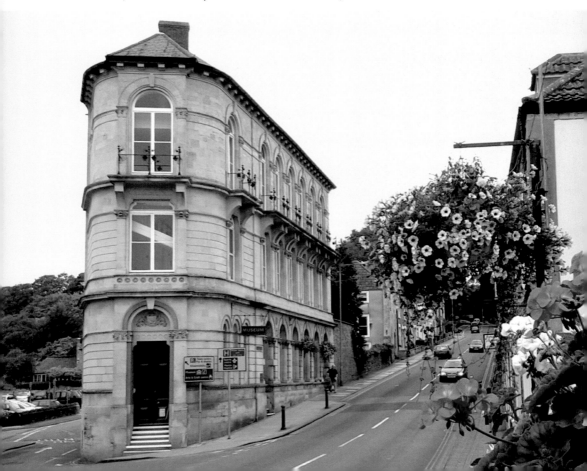

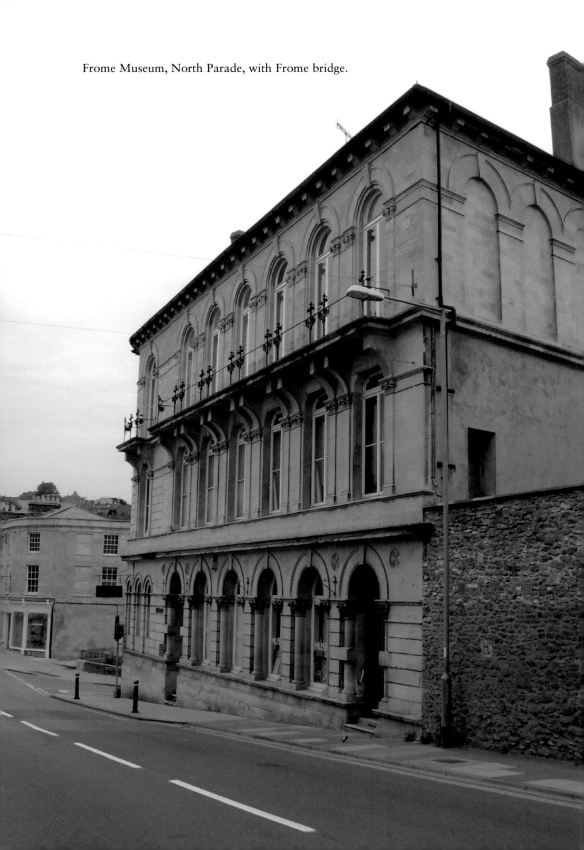

Frome Museum, North Parade, with Frome bridge.

in Palmer Street. After several plans for new premises, it moved to the new site and continued until *c*. 2000, and was then run as a private club. Sadly, the books and museum collection were either auctioned off in the late 1970s or lost when the Lit had become a private club and later a snooker hall. However, the Frome Society for Local Study had started a new museum in 1966 on Church Steps, before moving to Wine Street House and finally to the Lit. Frome Museum is now run by independent trustees and occupies the building. The museum has regular temporary and permanent exhibitions and an archive that records the economic and civic history and culture of the town and district.

49. Cheese and Grain (former Market Hall), Market Yard

There were a number of different markets in the town, such as the covered market (occupied by the NatWest Bank in 2021) in the Market Place and the regular market in Trinity. These were all combined under one roof in the new Market Hall in 1875, which had been designed by Warminster architect W. J. Stent and built by Frome builders F. & G. Brown for £2,445. Frome had been an agricultural centre for centuries but the Market Hall, next to the weekly market held in the Market Yard, made it a more important centre and increased the prosperity of the town. There was a lift behind the building, which gave access to railway sidings on the Radstock to Frome line so that produce could both be delivered from and loaded onto the railway. These sidings continued to be used until 1960 when transport by lorry replaced them.

In addition to providing premises to promote and sell local cheese and other products, it served for meetings and social events; for instance, it was here that the

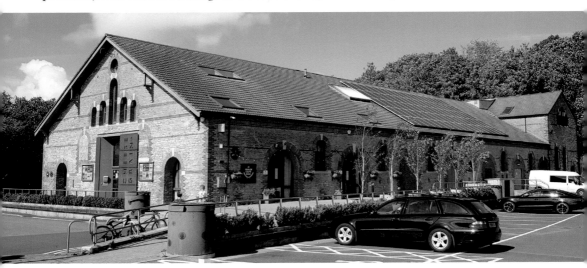

Cheese and Grain, former Market Hall.

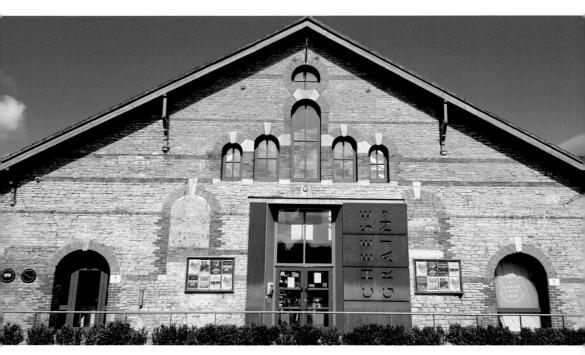

Cheese and Grain entrance.

Frome Amateur Operatic Society held their first performance in 1905 and it remained the main venue for concerts, exhibitions and meetings until Frome Memorial Hall opened in 1925. It was the primary site for the Frome Cheese Show, which took place annually in mid-September where the cheeses were tested, tasted and judged. During the First World War, J. W. Singer & Sons took over the building in 1915 to manufacture munitions such as fuse bodies, brass shell cases and aeroplane parts. It did not revert to public use until 1946 when Frome Urban District Council bought out the Market Company, which included the Market Hall. Later it was used for manufacture and storage of furniture by Benchairs and as a retail outlet for DIY sales.

In 1997 the building was purchased by Mendip District Council and leased to Frome Town Council, which renovated it to become a multipurpose venue for public meetings, regular sales and musical shows, together with a bar and café. The Frome Town Council has invested heavily in the building to make it a showcase for sustainability and flexibility.

50. Frome Town Hall, Christchurch Street West

Frome's first Public Office Building was built to house the Local Board of the Board of Guardians of the Frome Union and the Poor Law Union, starting in 1890. The architects were Halliday and Anderson of Cardiff, who designed

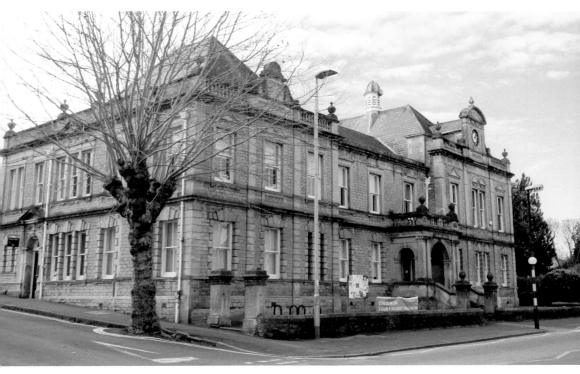

Above: Frome Town Hall, Park Road.

Below: Frome Town Hall, Christchurch Street West.

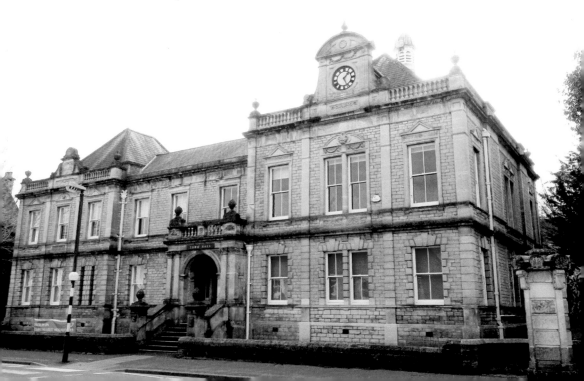

a building to recall the Italian Renaissance, and the builder was Joseph Bird of Radstock. Land was bought from Lord Bath for £178 and the building contract issued for £3,435. There were many problems in decision making by the Building Committee, particularly with finishes in the magnificent interior and the heating apparatus, which led to delays and disagreements between architect and builder; inevitably, there were cost overruns with the completion of such a grand design, which had to provide offices for the increasing activities of Local Government as shown by the plea to the Building Committee by the builder: 'It must be distinctly understood that I decline to take any responsibility for the delay neither can I bear the additional cost consequences thereon, especially in regard to the heating apparatus.' When the building had been completed, Alderman Edward Flatman, chairman of the board, offered to give a clock to finish the building, which was commissioned from Smiths of Derby and bears Alderman Flatman's name; a member of the public then complained that the clock should be illuminated!

Although it has been used for many public offices, particularly the Frome Urban District Council and the Frome Rural District Council from 1894 to 1974, it now houses the Frome Town Council offices, after having been sold to Frome for £275,000 by Somerset County Council.

The building is listed Grade II.

Acknowledgements

First and foremost, my thanks go to Peter Clark who convinced me to undertake the writing of this book. I have been helped by many friends and colleagues from the Frome Society for Local Study and Frome and District Civic Society, who have provided photographs and made several suggestions and corrections to the text. This book would not have been possible without the original research of Frome's foremost local historian, Michael McGarvie, and the definitive book *The Buildings of Frome* by the late Rodney Goodall.

I have been photographing and collecting photographs of Frome buildings for over thirty years but, sadly in many cases, I am not able to attribute them to each photographer correctly to thank them. However, I would like to thank Kate Yeates for permission to use her late husband Alan's photographs; I would also like to give special thanks to Joanna Rogers, who helped me with her skilled photography by taking many excellent photographs of buildings that were missing from my collection, and to Garfield Austin, Paul Boswell, Richard Downes, Robin Hill, Lockhart Murdoch, James Parsons and David Partner for permission to use their photographs.

Lastly, but not least, I thank my wife, Marie-Louise, and our children, Ian, Kenneth, Agnes, Rachel and Patrick, who have worked with us on our many building projects in and around Frome, supported the writing of this book, and particularly to Patrick for help in formatting and presentation.

About the Author

Alastair MacLeay was brought up in Kent and studied Applied Biochemistry and Malting and Brewing at Birmingham University. After a forty-year career brewing in England, Belgium and Ireland, he retired in 2000. He and his family have restored and renovated many derelict and semi-derelict buildings in and around Frome. He is a past chairman of the Frome and District Civic Society and the Frome Society for Local Study.